The Photographs of Homer Page

New York, May 30, 1949

The Photographs of Homer Page

The Guggenheim Year: New York, 1949–50

KEITH F. DAVIS

Hall Family Foundation

in association with

The Nelson-Atkins Museum of Art

Distributed by Yale University Press

New Haven and London

The Photographs of Homer Page
The Guggenheim Year: New York, 1949–50

Published to accompany an exhibition of the same title
at The Nelson-Atkins Museum of Art, February 14–June 7, 2009

This project is supported by grants from The Judith Rothschild Foundation
and the Hall Family Foundation.

With two exceptions (figures 1 and 28), all the photographs reproduced
in this volume are vintage gelatin-silver prints in the collection of
The Nelson-Atkins Museum of Art. Three of these—reproduced as plates
1, 38, and 48—are 2008 gifts of the Hall Family Foundation; the rest are
2005 gifts of Hallmark Cards, Inc. The works reproduced as figures 2
through 11, and as plates 35 and 43, are trimmed prints on exhibition
mounts; the rest are untrimmed and unmounted images on 11 x 14-inch
photographic paper. These images, and permission to cite Page's own
writings, courtesy Jeanne Russo Page or Christina Gardner.

Page's 1948 self-portrait (figure 1), from a digital scan of the original
negative, is courtesy Jeanne Russo Page and Don Heiny. Don Heiny's
late portrait of Page (figure 28) is courtesy the artist.

ISBN: 978-0-300-15443-6

Library of Congress Control Number: 2008944376

Copyright © 2009 by the Hall Family Foundation, Kansas City, Missouri,
and the Trustees of the Nelson Gallery Foundation, Kansas City, Missouri

Hall Family Foundation
P.O. Box 419580, MD 323
Kansas City, Missouri 64141-6580

The Nelson-Atkins Museum of Art
4525 Oak Street
Kansas City, Missouri 64111
www.nelson-atkins.org

Distributed by
Yale University Press
302 Temple Street
P.O. Box 209040
New Haven, Connecticut 06520-9040
www.yalebooks.com

Contents

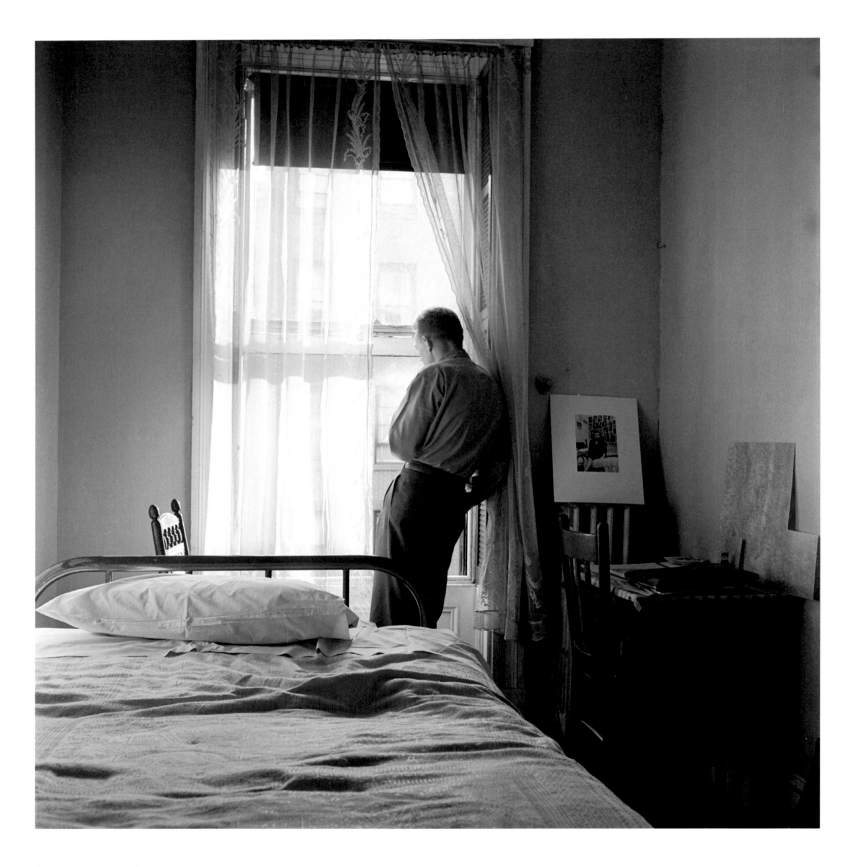

FIG. 1 *Self-Portrait, New York,* ca. 1948

Introduction

KEITH F. DAVIS

Curator of Photography

The Nelson-Atkins Museum of Art

To his friends and family, he was known simply as "Page." He was an unforgettable character: intense and smart; prone to passionate, if friendly, debates; tall and slim, with a singular quality of physical *presence*. From the time of his youth, Homer Page pursued his interests with an uncommon energy and a penchant for exploration and risk. He lived simply, perhaps even viscerally, in the present moment, propelled by a hunger to see and to understand the world around him. Page's artistic quest was all-consuming. His goals were enormously ambitious and he drove himself to accomplish them.

In no small measure, it was the vitality (and occasional contradictions) of Page's character that made him such a remarkable photographer. His most important work was achieved in only a few years, between about 1944 and 1950. The culmination of this intensely creative period was his finest work of all: the photographs he made as a Guggenheim Fellow, from April 15, 1949, to April 14, 1950. These twelve months were at once exhilarating and exhausting. Page worked with enormous dedication, challenging himself to question everything he knew about photography. He had begun with one set of ideas; gradually, through a relentless process of self-criticism, he came to another, more advanced conception. In so doing, he helped forge a new photographic vision—a fresh synthesis of documentary and artistic concerns, of objective fact and personal expression.

In his lifetime, Page's work failed to achieve the recognition it deserved. The New York book he hoped to publish in 1950 was stillborn in the mock-up stage—a result of his own perfectionism, his inability to find a sympathetic publisher, and the demands of earning a living. The book you hold in your hands—sixty years after the fact, and more than twenty years after his death—provides the first comprehensive study of Homer Page's photographs. This kind of retrospective "discovery" presents a significant art-historical challenge. The stylistic trends Page anticipated are, themselves, now history. This fact colors our understanding of his work in a fundamental way: we can only view it through the canonical framework of what came later.

This volume reflects a profound belief in the originality and importance of Page's achievement. His work provides a key missing link between two great eras of American photography: the humanistic, social-documentary vision of the Farm Security Administration and the Photo League of the 1930s and 1940s, and the more subjective, poetic, and expressionistic approach of a younger generation of 1950s street photographers. In essence, Page provides a previously unrecognized bridge between the artistic worlds of Dorothea Lange and Robert Frank. He was deeply sympathetic to the older tradition, while anticipating key elements of the creative movement to come. This vision—at once informed, personal, and prescient—put Page at the heart of the most vital artistic currents of his day. In rediscovering his achievement, we also gain a valuable new perspective on the creative energies of his time.

Acknowledgments

This project could not have been accomplished without the help, advice, and support of many people. My undying thanks go to two exceedingly important women in Page's life: Christina Gardner, of Santa Rosa, California, and Jeanne Russo Page, of Cornwall Bridge, Connecticut. Christina met Page in about 1940, married him, and witnessed his development as a photographer from the closest possible perspective. Although they separated in 1950 (and divorced in 1953), Christina has remained a staunch and unwavering advocate of Page's importance as a photographer. She has been unstintingly generous in the course of this project. She answered innumerable questions, provided access to her collection of letters and prints, and allowed me to read her lengthy and detailed manuscript on her years with Page. Her generosity and friendship have been critical to the success of this endeavor.

Jeanne Russo met Page in 1976, married him a few years later, and was with him until his death in 1985. In addition to overseeing and protecting his archive of negatives, prints, and papers, she has tended the Page flame selflessly. With careful consistency and enormous patience, she has helped push this project forward from its inception some years ago. My visits with her have been both enlightening and inspiring. I would like to think that I have absorbed some of the Page spirit not only by sitting in his study and at his dining room table, but by coming to know the people who loved him.

I am deeply grateful to Don Heiny, of West Cornwall, Connecticut. A fellow photographer, Don met Page in the mid-1960s and worked closely with him until the end of his life. Don has helped organize Page's archive and has a deep understanding of the work. He has provided varied and generous assistance with the research for this volume. He made copies of Page's papers (some of which have been included here as appendices) and, at a moment's notice, has been able to supply the most helpful names and dates. He provided a digital file of Page's New York self-portrait [FIG. 1], as well as his own, beautifully evocative portrait of Page later in life [FIG. 28]. In addition to his other virtues, Page was very wise in his choice of friends.

I am grateful to George R. Rinhart and Francis A. DiMauro, of Patterson, North Carolina, for assisting with the acquisition of the first group of Page prints to enter our collection. Mr. Rinhart's knowledge of the history of photography is legendary, and he has always had an unerring eye for the photographers who matter. When I first mentioned Page's name to him many years ago, I was not at all surprised that he knew it already. Tom Jacobson, of San Diego, California, helped in developing our collection of Page's work and provided some key bibliographic references. Thanks, too, to Howard Greenberg, of the Howard Greenberg Gallery, in New York, for his assistance and advice on this project. I also thank G. Thomas Tanselle, of the John Simon Guggenheim Memorial Foundation, in New York, for providing a copy of Page's Guggenheim application. Susan Ehrens and Leland Rice assisted in the early stages of this research by introducing me to

Christina Gardner and to several others who had known Page. Pirkle Jones, a former student of Page's at the California School of Fine Arts, generously shared his memories of him. Ira LaTour also provided a detailed reminiscence of that era. Inge Bondi, who worked at Magnum when Page was associated with the agency, kindly answered several questions about that period by email.

This book has benefitted from an enormously talented production team. Thomas Palmer, Newport, Rhode Island, produced the tritone separations; Malcolm Grear Designers, Providence, Rhode Island, designed the volume; and Meridian Printing, East Greenwich, Rhode Island, produced it. Special thanks go to Pat Appleton at Malcolm Grear and Daniel Frank at Meridian for their special care and attention. Thanks, too, to Liz Smith, Cary, North Carolina, for her patient and efficient editorial assistance, and to Trish Davis for her careful reading of the essay. Finally, the enthusiasm for this project of our distribution partner, Yale University Press, and particularly of Patricia J. Fidler, publisher, art and architecture, are sincerely appreciated.

Many eyes, minds, and hands have contributed to this effort. In Kansas City, thanks go to Shawn Pollock and Rich S. Vaughn, of Hallmark Cards, Inc., for their continued help and guidance. The work of conservator Mark Stevenson and of Tim Ward, Ward & Ward Custom Picture Framing, is also greatly appreciated.

At The Nelson-Atkins Museum of Art, thanks go to Chelsea Schlievert, for her long-time assistance on this project, and to photography department members April M. Watson, associate curator, Natalie Boten, department coordinator, and Bret Gottschall, preparator. Special thanks go to assistant curator Jane L. Aspinwall for her research assistance and for assembling the bibliography of this volume. Many other museum personnel helped in the course of this project and in the preparation of the accompanying exhibition. These include museum director Marc F. Wilson; chief curator Deborah Emont Scott; curator, exhibitions management, Cindy Cart; Lou Meluso and the staff of the museum's imaging services department; registrar Julie Mattson; John Hamann, of the museum's bookstore; Ann Friedman, manager, grants and foundations; and Jeff Weidman and Roberta Wagener, of the Spencer Reference Art Library.

The Judith Rothschild Foundation provided welcome support for this book and the accompanying exhibition. Our sincere thanks go to Elizabeth Slater, senior vice president, and Harvey S. Shipley Miller, trustee, and to the 2008 Rothschild Foundation grants review committee. The support of the Hall Family Foundation is very deeply appreciated, with sincere thanks to Bill A. Hall, president; Terri R. Maybee, director; and Karen Beckett, private controller. As always, Donald J. Hall's commitment and vision have been fundamental to this overall effort.

K. F. D.

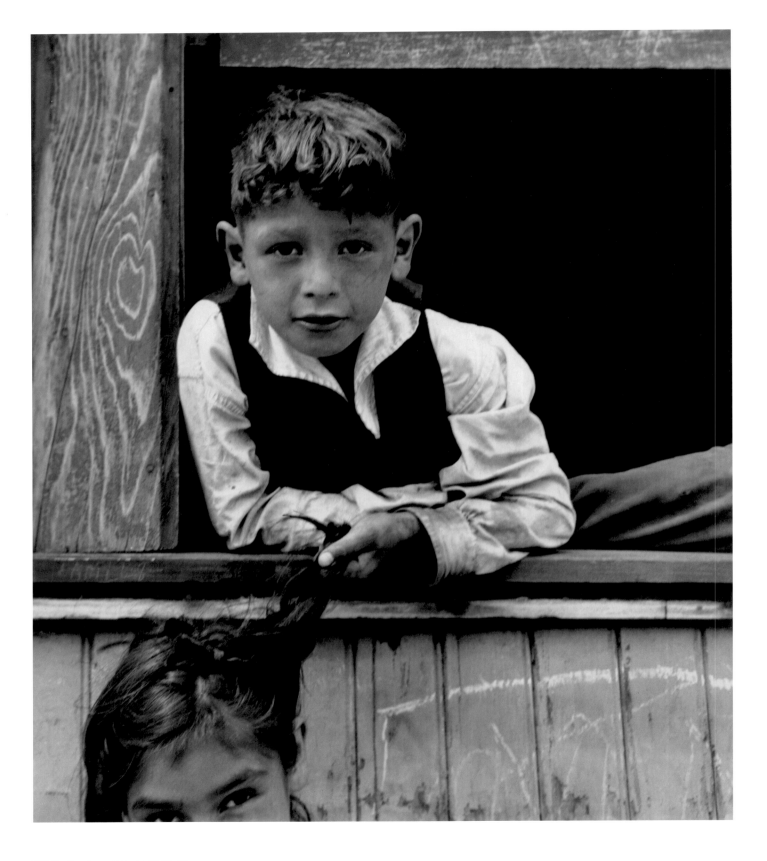

FIG. 2 *San Francisco*, ca. 1945–48

"Little Alternative But to Follow My Eye"

Homer Page and the "Documentary Idea"

On the evening of November 20, 1950, a symposium titled "What Is Modern Photography?" was held at the Museum of Modern Art. It was the photographic event of the season. The proceedings were broadcast live on WNYC radio and taped for replay overseas on the State Department's Voice of America.[1] The auditorium was filled to capacity; a crowd of more than five hundred had come to hear ten of the nation's leading photographers discuss the state of their art. Introduced by Edward Steichen, the museum's curator of photography, this group comprised Margaret Bourke-White, Walker Evans, Gjon Mili, Lisette Model, Wright Morris, Homer Page, Irving Penn, Ben Shahn, Charles Sheeler, and Aaron Siskind. It was a veritable Who's Who of American photography.

Steichen selected these speakers both for their individual reputations in the field, and for the diversity of their approaches. Homer Page, one of the youngest of the group, was chosen to speak on new trends in documentary photography—work that explored, in Steichen's words, "what we are like and how we live."[2] Page was succinct, thoughtful, and generous in his comments:

> I have felt some responsibility to talk a little bit tonight about the new directions that young so-called documentary photographers are taking. I think these directions are important, and will become more important as time goes on. In general, I think there has been a trend away from the old documentary standby of objective reporting toward a more intimate, personal, and subjective way of photographing.
>
> I think, specifically, there are two trends that seem to me to be very important. One trend has a positive note to it. It records life as healthy, vigorous, and even sometimes humorous. It does this without being insipid. I think it's something new and welcome in this field which has been criticized so often for photographing despair and deprivation. Two people particularly, Ruth Orkin and Tosh Matsumoto, are important here and very representative. Their photographs are very easy to look at. Their photographs make you want to laugh, or at least to smile to yourself. All in all, they leave you with the feeling that all is not lost in this world of ours.
>
> The other trend leads off in the opposite direction. It's an attempt to get at new kinds of realities—realities which the clear, explicit images of much of the former documentary work were unable to record. For this reason, many of the people important in this trend are breaking up their images. They are concerned, I think, not so much with the "what" of life, but with the "why." They ask questions rather than answer them. In this regard, Louis Faurer is a very good and very representative photographer. My own impression of his work is that it is probing and disturbing—and strangely poetic. He brings the old reality to you through new eyes. His images are, to me, quite exciting. [They] leave me restive and wondering. He has captured a certain amount of mystery in his images and there is room in them for your mind to roam and explore.
>
> I think both of these trends, although quite dissimilar, are healthy. The first is overtly so, and the second because it records the turmoil and perhaps the confusion that we all feel to some extent in this world today. I think they will gain support from other young photographers as time goes on. As a matter of fact, the people I have mentioned are representative, but there are many other people who are working in these directions. And as time goes by, they will become valuable additions to the group and to the documentary idea.[3]

Today, nearly sixty years later, Page's insights ring remarkably true. He pinpointed a key distinction in the era: the split between a gentle,

overtly humanist approach to the contemporary social scene, and an edgier, more "probing and disturbing" vision. One represented a spirit of affection and affirmation; the other, a mood of poetic uncertainty and critique. Page emphasized the value of both approaches to a larger "documentary idea"—the project of using the camera to better understand contemporary society.

Page's magnanimous words about Ruth Orkin, Tosh Matsumoto, and Louis Faurer reflected a genuine understanding of their work. In truth, however, both creative approaches were embodied in Page's own photographs. He fully grasped the central challenge for "documentary" (or "street") photographers of the period. After great struggle, he had forged a powerful and purely individual synthesis of the approaches he outlined in his symposium remarks. His photographs provided a fresh and encompassing visual model—one that paid homage to the vital currents of past practice, while looking forward to a new, tougher, and more critical vision. What must be rediscovered today was obvious to many at the time—Page had been chosen to talk on this subject because he exemplified the most advanced state of this facet of photographic practice.

Who was Homer Page and what did he accomplish as a photographer? Nearly sixty years after the event, nine of the ten speakers in the "What Is Modern Photography?" symposium are firmly ensconced in the "pantheon" of twentieth-century photography. But the tenth, Homer Page, has slipped almost completely out of photo-historical memory. This essay seeks to explain why he was part of that distinguished gathering in 1950, and why he deserves to be remembered and celebrated today.

BECOMING A PHOTOGRAPHER

Homer Gordon Page was born in Oakland, California, on August 4, 1918, the youngest of the three sons of Alva Francis Page and Eva Elvira (Ten Eyck) Page.[4] Alva Page was a real estate developer in the Los Angeles and Oakland areas. He was also a semi-pro boxer and an avid member of the Olympic Club in San Francisco. The elder Page taught his sons to box, instilling in them a sense of confidence, strength, and quickness. A forceful man, Alva Page was very conservative in his politics, with a firm sense of right and wrong. He achieved considerable financial success but lost nearly everything in the Great Depression. Eva Page was a refined and proper woman—she was, for example, never seen in public without her hat. Soft-spoken and retiring by nature, she was nevertheless

something of a social pioneer. During World War II, when the neighborhood around them turned from white to predominately African American, she left her long-time white dentist for a black one closer to home. At a time of pervasive and often unquestioned racism, this was a rather bold statement of principle.

Page did not share his mother's quiet demeanor or sense of propriety, but he was influenced by her commitment to social justice. He loved many of his father's traits, but disowned his conservative views and rejected a life in business. In part, this repudiation stemmed from the family's financial losses in the 1930s, when the son was of a particularly impressionable age. He, like so many others of his generation, felt little allegiance to the existing—and apparently failed—political and economic order. Instead, Page inclined to a life of creative independence, and with it, a chronically irregular (and only marginally adequate) income.

Page pursued many interests in his youth, including photography. In 1930, he was one of the hundreds of thousands of American children who received a free Brownie box camera from the Eastman Kodak company. In this massive promotional effort, celebrating its fiftieth anniversary, the venerable Rochester, New York, firm distributed cameras to a half million children born in 1918. Page's interest advanced during his high school years in Los Angeles, when he bought a 35mm Argus camera and an enlarger and began "shooting candids" in the city's tough Pershing Square district.[5] After graduating from Los Angeles High School as an art major, he enrolled in the University of California, Los Angeles's College of Commerce. One year later, he transferred to the university's Berkeley campus, where he changed majors several times, from business administration, to social psychology, to art.[6] Along the way, he became aware of the work of Alfred Stieglitz and, by 1939 or 1940, Walker Evans's landmark book *American Photographs* (1938).

Page's education in photography advanced rapidly in 1939–40, when he met both Christina Gardner and the Hungarian avant-gardist László Moholy-Nagy.[7] He met Gardner, a fellow Berkeley student, in late 1939 or early 1940, and they married within a year. From the first, Gardner sensed that Page was "a person of smoldering talent." She loved his spontaneous energy, his forceful opinions, and his wit.[8] Page, in turn, must have been pleased to have his photographic interests reinforced—and even amplified—by Gardner's. When they met, Gardner had a serious interest in photography and owned a 3¼ x 4¼-inch Speed Graphic view camera. Her enthusiasm for the medium dated back many years, from the time of her first visit to the studio of noted photographer Dorothea Lange. Gardner's mother was a long-time

friend of Lange's, and Gardner had been inspired by her childhood visits to Lange's portrait studio in Berkeley.

In the summer of 1940, the landscape photographer Ansel Adams organized a large survey exhibition, "Pageant of Photography," at the Palace of Fine Arts at the Golden Gate International Exposition.[9] This ambitious show—which Page almost certainly visited—included nineteenth-century photographs, a survey of recent documentary work, and prints by such prominent contemporary artists as Paul Strand, Edward Weston, Charles Sheeler, and László Moholy-Nagy. This exhibition was of such importance that a number of institutions in the Bay Area planned complementary photography events around it. As part of this effort, Moholy-Nagy was brought to Mills College, in Oakland, to teach a summer workshop.

By 1940, László Moholy-Nagy was a figure of some art-world renown. Born in Hungary, he had been a key member of the European avant-garde of the 1920s and an influential teacher at the Bauhaus, in Weimar, Germany, from 1923 to 1928. After a successful career in Europe, Moholy-Nagy was brought to Chicago in 1937 to establish a school of design. His New Bauhaus attracted a number of enthusiastic students in its first year, but closed for lack of funding. Moholy-Nagy tried again, opening the School of Design in early 1939. (With continuing financial troubles, this became the Institute of Design five years later.) Moholy-Nagy's 1940 summer session at Mills College was typical of his outreach efforts of this era (intended, in part, to promote his fledgling program in Chicago).

Moholy-Nagy was a tireless advocate of artistic modernism. His overall subject was *design*, the underlying principles of all visual communication, from fine art to the most utilitarian commercial products, packaging, and advertising. Photography played an important role in Moholy-Nagy's pedagogy. As the most technologically advanced of the visual arts, it embodied the new aesthetic potentials of the industrial age. Moholy-Nagy stressed that the medium had an expressive language entirely its own, founded on the most fundamental photographic fact: the action of light on a light-sensitive surface. To this end, he urged beginning students to make photograms—cameraless images produced in the darkroom by shining light directly on sheets of photographic paper. Further exercises explored the expressive possibilities of many other aspects of the process: manipulations of the camera's lens and shutter, the use of unusual vantage points, multiple exposures, and more.

Page met Moholy-Nagy at the Mills College sessions. Moholy-Nagy offered him a scholarship to the School of Design, and Page happily accepted. He moved from Berkeley to Chicago for the beginning of the 1940 fall term, and remained there through the spring 1941 semester.

Page's year at the School of Design was enormously stimulating. While it sometimes appeared that there was scarcely enough money to keep the lights on, the school was vibrantly alive with ideas and experiments, questions and debates. Several of his classmates—including Milton Halberstadt, with whom he shared a house—became close friends. Page, officially in the industrial design program, applied himself to all his subjects, from physics and biology to sculpture, drafting, and lettering. In his photography classes, following Moholy-Nagy's curriculum, Page explored various aspects of the medium, beginning with the serendipitous discoveries of the photogram [FIG. 3]. Outside of class, he gained a more technical understanding of photography from Halberstadt, who knew as much about the subject as any of the school's instructors.

When Page returned to Berkeley in late spring 1941, war loomed ever larger. Christina completed her final semester at the University of California that fall, while Page worked at a glass company. Their lives changed with Pearl Harbor and the nation's entry into World War II. When he reported for his draft review, Page was surprised to be given a 4F classification due to a punctured eardrum. Wanting to contribute to the war effort, he found work on the swing shift at the Kaiser Shipyards, Richmond No. 1. He worked at the shipyards for the first several years of the war, while taking classes during the day at the University of California. Page loved the hard, honest labor of the shipyards and the earthy, no-nonsense attitude of his fellow workers.

In this period, Christina worked as Dorothea Lange's photographic assistant. Lange was just beginning a project documenting the process and results of Executive Order 9066. Signed by President Roosevelt on February 19, 1942, this ruling required military authorities to intern any Americans suspected of posing a national security risk.[10] Controversially, it was applied to an entire ethnic group: all persons of Japanese ancestry living on the Pacific coast. Held at first in urban assembly centers, these bewildered citizens—none of whom had been accused of a specific crime—were then shipped to internment camps in remote inland areas. Enacted at a moment of fervent anti-Japanese sentiment, this policy elicited only scattered public protests. Lange disagreed strongly with the ruling, viewing it as both inhumane and unnecessary, but accepted the assignment, in part, to see firsthand what was happening. Christina worked closely with Lange, assisting her both in the field and in her studio at home. This was an intense and emotionally draining experience for both of them—and a powerful reminder of

FIG. 3 *Photogram*, ca. 1940

photography's value in bearing witness to events of social and historical importance.

The Pages' connection to Lange soon became even stronger. In the spring of 1943, Christina gave birth to a daughter, Saaren. About six months later, the three were forced to relocate when the owner of their rental property returned from military duty. Rental houses were nearly impossible to find during the war, but Lange offered the family a tiny garden cottage behind her own house in Berkeley.

Christina remembers the "garden cottage years" as sunny and idyllic. Their cottage was small, but beautifully situated under a canopy of oak trees, adjacent to a park. Most important, it was just behind the home of Lange and her husband, Paul Schuster Taylor, a respected professor of economics at the University of California, Berkeley. The Pages were welcomed into the Lange/Taylor household with open arms, as virtual family members.

The Lange/Taylor household represented both a warm domestic realm and a hotbed of ideas. Lange was recognized as one of the nation's greatest photographers. After beginning her career as a portraitist in San Francisco, Lange had been compelled by the crisis of the Depression to turn to social documentary work. Her images of the unemployed and the dispossessed led to an affiliation with the federal government's Resettlement Administration and Farm Security Administration documentary projects from 1935 to 1939. Lange's iconic images of these years revealed the human cost of the Depression and Dust Bowl. The power of her photographs stemmed from their telling details, particularly those of body language, expression, and gesture. Used widely by the government and national media, Lange's photographs came virtually to define, in visual terms, a national calamity. Together, Lange and Taylor also published one of the definitive documentary books of the period, *An American Exodus: A Record of Human Erosion* (1939).

Paul Schuster Taylor taught economics at the University of California-Berkeley from 1922 until his retirement in 1962. Known as a progressive agricultural economist, Taylor's early work focused on Mexican immigrants and Mexican American field laborers. During the Depression, his interests broadened to include the plight of sharecroppers, tenant farmers, and migrant farm workers throughout the West. Taylor and Lange began working together in the field in 1935. Their collaborative reports to state and federal authorities succeeded in gaining relief funds to house impoverished migrant laborers. A proud liberal and supporter of President Roosevelt's New Deal agenda, Taylor was unafraid of con-

troversy. In early 1942, for example, he was one of the few public figures to speak out against the internment of Japanese American citizens.

Taylor and Lange complemented each other seamlessly in their professional work. Both were concerned with the essential fabric of American society, questions of political and economic justice, and the plight of the working poor. Lange took an artist's approach to these themes, exploring them in visual terms. As a social scientist, Taylor marshaled statistics and detailed case studies in closely reasoned arguments for political action.

In 1944, when the Pages moved into the garden cottage, Lange and Taylor were in a relatively quiet stage of their lives. In 1940, Lange had done some work in California and Arizona for the Bureau of Agricultural Economics. In 1941, she applied for and received a Guggenheim Fellowship to document the social patterns of communities in the rural West. In her own words, she sought to record "people in their relations to their institutions, to their fellow men, and to the land."[11] Unfortunately, this ambitious project was cut short by a family crisis (the arrest of her brother for financial fraud) and the Japanese attack on Pearl Harbor. Lange applied for an extension of her fellowship period, but was never able to resume the work. There followed a commission from the War Relocation Authority in 1942 and, beginning in 1943, an assignment for the Office of War Information. All of this work was hampered by severe bouts of illness which kept Lange close to home during much of this period.[12]

It was in this stimulating and nurturing environment that Page determined that he would be a photographer. In 1944, feeling flush with his $77.22 weekly paycheck from the shipyard, he and Christina splurged on a gently used Rolleiflex 2¼ x 2¼-inch format camera.[13] Although the couple had originally planned to share it, the new camera almost immediately became Page's alone. He loved the Rolleiflex and handled it with instinctive dexterity. With this new tool, his simmering desire to "make his mark on the world"—which Christina had sensed on the day they met—was realized.[14]

Page began by photographing what he knew: the bustling area around the Richmond shipyards. Richmond was a potent symbol of the domestic war effort: almost overnight, this formerly quiet community of twenty thousand people had become an industrial city of more than one hundred thousand workers.[15] Thanks to a wartime boom that has been described as a "Second Gold Rush," the East Bay area was a subject of considerable sociological and journalistic interest. Lange began

photographing there in about 1942.[16] Not surprisingly, she asked Page for advice on potential subjects. Christina, in turn, accompanied Lange in the field, making notes for captions. Given Lange's enthusiasm for this subject, it was even more natural for Page to begin his personal work in photography there.

Because of concerns about espionage, cameras were strictly regulated within the shipyards themselves. Thus, by necessity, Page became a street photographer.[17] Rolleiflex in hand, he prowled the town, recording shoppers, couples, and kids on the sidewalk. He was particularly interested in the tidal flow of workers commuting to and from their jobs each day. This theme—the strict clockwork of modern labor—engaged him for several years. He perceived this near-silent flood of humanity with detached sympathy; it was, in many respects, a perfect symbol of the values (of his father) that felt so alien to him.

From the beginning, Page's work was encouraged and critiqued by Lange. She also suggested that he send prints to the Museum of Modern Art, in New York. He did so, and in response, acting curator Nancy Newhall (filling in for her husband, Beaumont Newhall, who was away in the war) wrote an encouraging—if constructively direct—letter of thanks, with an invitation to send further examples of work. At about the same time, one of his photographs was published with sympathetic commentary by Ansel Adams in the August 1944 issue of *U.S. Camera* magazine. In only a matter of months, Page had been published in a respected national journal and encouraged by the nation's leading curator of photography. He was off and running.

Page's next project, begun in the summer of 1944, had a tighter and more challenging thematic focus. This series began as an investigation of juvenile delinquency, but it soon took a more open-ended title, "The Question of the Kids." Through the advice of a social worker friend, Page photographed in the Mission district of San Francisco, which had one of the highest rates of juvenile offense in the Bay Area. He worked intently on the project for two weeks, producing a number of strong and evocative images.

This work brought him considerable recognition in the following two years. Nancy Newhall reviewed prints from this group in October 1944 and wrote a warm note in return. She deemed the work significant enough to show it to Paul Strand, one of the most revered creative photographers of the period. Four of these prints were presented in a group show at Mills College, in Oakland, that year. The series received national exposure in 1946. A lengthy article on the project, written by Christina,

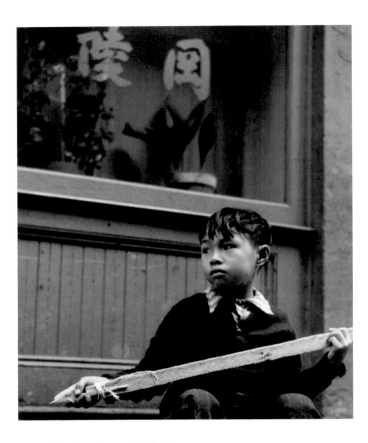

FIG. 4 *San Francisco*, ca. 1945–46

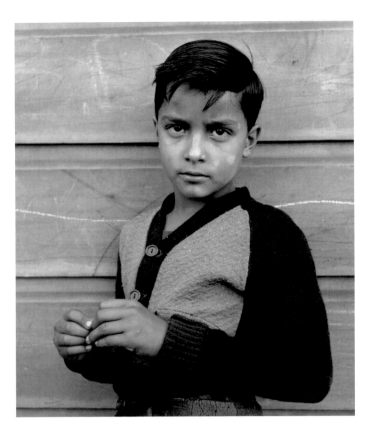

FIG. 5 *San Francisco*, ca. 1945–46

was published in the February 1946 issue of *Minicam* magazine.[18] Several other prints from this series were included in Page's debut at the Museum of Modern Art, as one of seventeen young talents in a group show in the summer of 1946.[19]

The increased ambition of "The Question of the Kids" forced Page to wrestle with important questions about his working method. In large measure, these revolved around a fundamental issue: the tension between social science and art, fact and expression. Was his ultimate goal social analysis or memorable pictures? Were these images intended for himself or to serve an educational and political function? What was Page's primary subject: the world around him or the one within?

While nearly every good photographer wrestles with some version of these questions, the problem was particularly acute for Page. From the beginning, he had shown an interest in both the arts and the social sciences, shifting the focus of his college studies between business, social psychology, and art. Page had the instincts of a liberal reformer as well as an artist's desire for self-expression. On one hand, he valued the experimental daring of Moholy-Nagy and the aestheticism of the

Museum of Modern Art; on the other, he revered the standard of social concern and analysis set by Lange and Taylor. These instincts had to be examined and reconciled for him to mature as a photographer.

Page's greatest problem with "The Question of the Kids" involved the use of words. At the time, Page was convinced that "words and pictures are necessary to each other to form an integrated unit," but he was never fully satisfied with his results.[20] He and Christina agonized over captions for these pictures, Lange and Taylor both offered advice, and other friends were pulled into the process. Over the next two years, Page grouped and regrouped his prints in thematic categories with tentative titles such as "Some of the Successful," "The High Cost of Diversion," "The Low Cost of Being Alive," and "Some Ways of Being Alone."[21]

It took several years to work through these problems. Page knew from the start that he had no desire to produce the kind of captions that Lange employed. As Christina has observed, Lange's approach "was based on a sort of sociological caseworker method."[22] Lange nearly always traveled with an assistant who took detailed notes on the time, place, and circumstances of what she was photographing. In addition,

Lange had a remarkable memory for what her subjects said, and how they said it. This information was recorded in her field notes, and used (sometimes as direct quotation) in her captions. This approach was entirely appropriate for projects designed to serve official state or federal purposes. It was considerably less useful for more personal, or deliberately poetic, bodies of work.

Page's ambivalence over the matter of explanatory texts was a direct reflection of his inner drives and inclinations. He had a quick intelligence and a deep sense of curiosity, but he was not a natural researcher or scholar. He absorbed information by living, talking, and observing, as much as by reading. As Christina has noted,

> Page's was the kind of intelligence that always seemed to capture important thoughts floating by in the world around him, but he was not what I think most people mean by an "intellectual." He didn't read that much but he seemed to know a great many things anyway, even contemporary happenings although I don't think I ever knew him to read a newspaper regularly. I think few things that he read actually changed his mind about any given photo project, but every item he raked out about his subject seems to have sharpened his own inner image of what he was trying to do.[23]

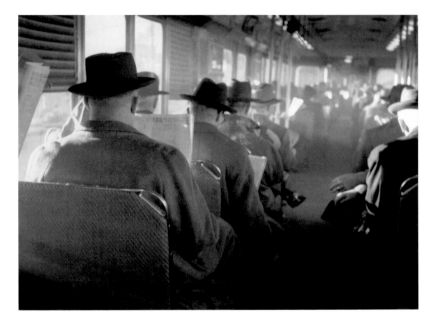

FIG. 6 *San Francisco,* ca. 1945–46

While Page aimed for both a visceral and an intellectual understanding of his subjects, he knew that he naturally inclined to the former.

This tendency underlay an extended struggle with yet another aspect of the picture/word problem. This involved the choice, in any single body of work, of following a predetermined methodology or script versus the more intuitive approach of discovering a subject in the process of engaging it. How tightly conceived should a photographic project be? What role should intuition and chance be expected to play? At what point might research and analysis cease to benefit the picture-making process? Ultimately, perhaps, the question was: What is the relationship between the quality of one's thesis and the life of one's photographs? These and similar questions remained vital for Page in the coming years.

In 1944–48, Page undertook a number of personal projects, gaining confidence as an artist as he explored various ideas and approaches. Beginning with "The Question of the Kids," he paid repeated attention to children and adolescents. These images reveal a richly multifaceted vision, by turns dynamic, contemplative, somber, and whimsical [FIGS. 2,4,5]. Following his early interest in the commuters of Richmond, he made other photographs of the rhythms of white-collar workers traveling to and from their jobs in San Francisco [FIG. 6]. He walked streets throughout the Bay Area, recording pedestrians, buildings, automo-

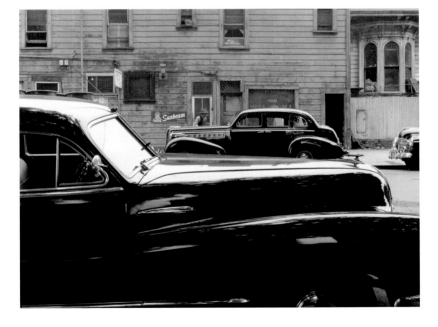

FIG. 7 *San Francisco,* ca. 1945–48

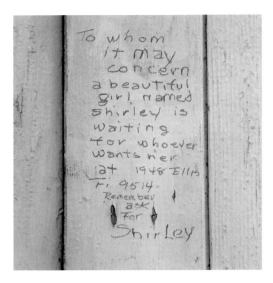

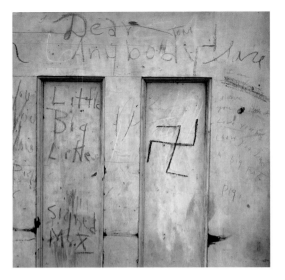

18

biles, signs, and graffiti—anything that conveyed some resonant facet of contemporary experience [**FIGS**. 7–10]. Spurred by his fascination for skilled laborers, Page also made a series of images of Longshoremen loading cargo vessels on the waterfront.

One of his most notable series of this era was made at an American Legion convention in San Francisco in 1946. Page photographed the participants in their official sessions, on the streets, and in bars. These pictures reveal his growing maturity as an artist: they are by turns sardonic, poignant, and ironic. One of the most remarkable of these [**FIG. 11**] suggests a surrealist collage: two faces seemingly jammed together to create a bizarre caricature. This work nicely illustrates the distinction between documentary and expressive impulses. This startling picture has little to do with an "objective" sense of reportage: it is an expression of Page's own quirky and irreverent sensibility.

The energy of Page's photographs was, in part, a result of his unconventional technique. His twin-lens Rolleiflex camera was intended to be held immobile in the hands at chest or waist level. In this position, the photographer framed the scene to be captured on film by looking downward into the camera's viewer. This is a curiously oblique way of recording people, with the photographer looking 90 degrees away from his subject at the moment of exposure. While this style of "reflex camera" was easily carried in the hand, it was not capable of the split-second immediacy of the then-new 35mm camera, which functioned as a direct

extension of the eye. However, the Rolleiflex had other virtues: it had superb optics and produced a negative more than three times the size (and therefore the detail) of a 35mm camera.

Page found a way to use this somewhat awkward tool with an astonishing spontaneity. Through repeated practice, he learned to focus by feel alone. He inserted a metal pin in the camera's focusing knob and learned by touch to correlate the angle of the pin with the focal distance of the lens. This allowed him to work while in motion on the sidewalk. As he strolled toward a possible subject, for example, he might decide to take a shot from a distance of twelve feet. From a nearly unconscious instinct, he would nudge the focusing knob into the appropriate position. Approaching his mental twelve-foot mark, he would raise the camera to chest level, aim it intuitively (typically, without looking in the viewfinder), and press the shutter release. This was a fluid, seamless act, requiring only a few seconds. While his framing might have been only approximate, Page's generous negative gave him the latitude to crop unwanted peripheral details out of his final print. This technique had something in common with his early training as a boxer: it was all about anticipation, balance, efficiency, and quickness. It also gave Page an enormous creative advantage on the street: it rendered him effectively invisible as a photographer.

One of the boldest results of Page's technique is this image of a striding woman [**FIG. 12**], from about 1947. This tightly cropped view of

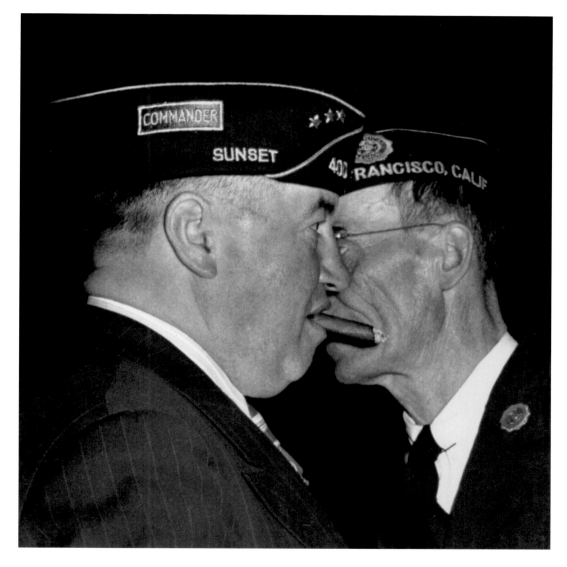

FIG. 11 *American Legion, San Francisco*, 1946

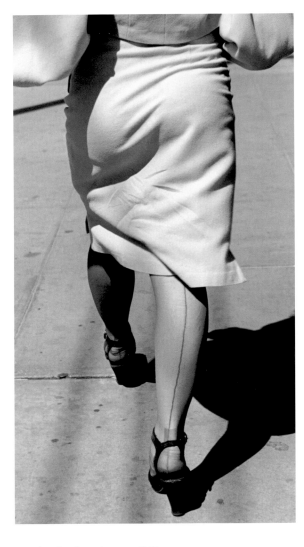

FIG. 12 *San Francisco, ca. 1947*

the lower half of a figure is overtly sexual—a near textbook example of the voyeurism that some would argue is central to the (male-dominated) practice of street photography.[24] In addition, however, it is a striking symbol of the times: a well-dressed young woman, with flawless stockings and heels, strides with muscular confidence down an urban sidewalk. It is a high-key image, radiant with light and life. Her identity is not revealed; she remains a gleaming symbol of a new, postwar American woman. Edward Steichen, by 1947 the curator of photography at the Museum of Modern Art, loved this print. He dubbed it a "Modern Winged Victory," and included it in several exhibits at the museum over the years.

Page's devotion to photography spurred a change in his career path. By 1944, he had quit his job at the shipyards to pursue his livelihood with the camera.[25] He worked briefly for a San Francisco commercial photographer named Cristof, but then moved to the older and larger studio of Gabriel Moulin. This was a no-nonsense commercial business; Moulin photographers carried out a wide variety of assignments, typically with more efficiency than imagination.[26] Nonetheless, Page learned a great deal. He worked in both the studio and the field, with cameras ranging in format from 35mm to 11 x 14 inches, and was able to try his hand at advertising, fashion, industrial, publicity, and news photography.[27] With this experience, he was hired in 1945 as the official photographer for the Associated Students of the University of California. This student organization had an unending need for photographs of all kinds of subjects, from athletic events to portraits of football stars and Nobel Prize-winning faculty members. Page liked the variety of these assignments, and the four-day work week gave him time for his own photography.

In 1947, Page also began teaching part-time at the California School of Fine Arts (now the San Francisco Art Institute).[28] The school's interest in photography had been stimulated by a series of lectures given there in 1944 by Ansel Adams. These talks attracted an enthusiastic and knowledgeable audience, including Page, Lange, and Taylor.[29] The school created a full-fledged department of photography in 1946 under the direction of Adams and his assistant, Minor White.[30]

Students at the California School of Fine Arts were offered a diverse and stimulating program—one with a clear debt to Moholy-Nagy's example in Chicago. Beginning photography majors were required to take a survey of modern art and ideas titled "Design, Society, Artist." This was followed by a series of other foundational classes—"Drawing and Composition," "Color Control," and "Life Sketch"—taught by the school's distinguished painting faculty.[31] A first-year required course introduced the basics of photography, its expressive applications, and

its creative history. Second-year students focused on more specialized applications such as portraiture, landscape work, commercial illustration, and photojournalism and documentary practice. Other classes and seminars were offered in both the school's day schedule and its less intensive evening program. This curriculum was supplemented by guest lecturers, including such noted Bay Area figures as Dorothea Lange, Imogen Cunningham, and Edward Weston, and the New York photographer Lisette Model.

Page was hired for his expertise in two subjects: documentary practice [APPENDIX A] and the use of the small camera. As his classroom notes reveal, Page also taught a variety of technical matters, some history, and issues of critical thinking.[32] He was, by all accounts, a very articulate and effective teacher. The quality of his instruction is suggested by the fact that it was the best students who appreciated him the most.[33]

The teaching of photography was (and for many years, remained) founded on the tripod-mounted, single-shot 4 x 5-inch view camera—the key tool of commercial and artistic practice. By contrast, the hand camera (with its rapid-exposure roll-film technology) was considered an intriguing but imprecise tool, of value primarily to amateurs. Page was by no means the only artistic photographer of the day to work with a roll-film camera. However, he was notable for choosing to use it exclusively and for his uniquely dynamic technique. As Page well knew, the small camera opened new worlds for photographers—it revealed a visual realm beyond the capabilities of larger, slower, sheet-film cameras.

In his documentary class, Page promoted a broad view of the medium's history and visual traditions. He began with the Civil War photographs of Mathew B. Brady, Alexander Gardner, and George N. Barnard, and the early twentieth-century work of Lewis Hine and Arnold Genthe. He then discussed the great artistic triumvirate of Alfred Stieglitz, Paul Strand, and Edward Steichen; the leading photographers of the 1930s Farm Security Administration, including Lange, Walker Evans, Arthur Rothstein, and Russell Lee; and the more recent efforts of the New York Photo League. A constant point of emphasis (written boldly in his lecture notes) was: "These people were concerned with their time as a moment in history."[34] Page urged his students to be similarly aware of the unique historical value of the present.

Page's thoughts on documentary practice were informed by the challenges he faced in his own work. He cited Dorothea Lange's observation that a photographer "can never cover anything"; every body of work could only be a selection from, and an interpretation of, a much larger reality. The photographer's choices, in turn, were based on his or her feelings about, and understanding of, the subject. Page emphasized the frequent tension "between what you observe to be true and what you feel should be true." Ultimately, he outlined the key problem as "getting below the surface aspects to catch indications of motivation."[35] In his notes for another seminar, Page addressed the components of photographic vision in admirably concise form:

I. Tools (equipment and supplies)
II. Methods (semantics)
III. Interpretation (philosophy)

This brief outline suggests a clear understanding of photography as a technical problem, an eloquent visual language, and a means of engaging the most significant ideas of the day.

Despite his effectiveness in the classroom, Page taught at the California School of Fine Arts for only one academic year, from fall 1947 through spring 1948. One reason for this may have been some disagreements with Minor White, who had taken over directorship of the department from Ansel Adams. Ultimately, however, Page probably never felt fully comfortable in the classroom: he was more interested in making photographs than in teaching others to do so.

By this time, Page was talking increasingly of going to New York. The city was the center of the photography world: the hub of the nation's publishing industry and home to the field's most important art institution, the Museum of Modern Art. Feeling that he had learned what he could from the people and resources of the Bay Area, Page sought fresh opportunities. He was also eager for the challenge of taking on the nation's greatest city as his subject.

Page had grown enormously as a photographer between 1944 and 1948. With his connections to both Lange and the California School of Fine Arts, he had come to know many important figures. Most importantly, his national reputation had been boosted significantly by the support of Edward Steichen, who replaced Beaumont Newhall as the Museum of Modern Art's curator of photography in 1947. Indeed, the first of Steichen's many shows at the Modern, in October 1947, was "Three Young Photographers: Leonard McCombe, Wayne Miller, Homer Page." This exhibition included a dozen of Page's prints, with an emphasis on his American Legion series. Steichen included Page's work in two group exhibitions in 1948: three prints in "In and Out of Focus," in April, and one in "50 Photographs by 50 Photographers," in July. By this time, Page had grown beyond the status of a merely regional talent; he was a photographer of national renown.

Steichen was instrumental in Page's move to New York. The two first met in 1947, over dinner at Lange's house. In his new role as curator at the Museum of Modern Art, Steichen was visiting the Bay Area to learn more about the local photography scene. While Steichen had already given Page's work his stamp of approval, this meeting led to a more personal friendship. The older man was cautious about Page's desire to leave the Bay Area, stressing the competitive challenges in New York and the benefits of Page's current life.[36] Page grasped the wisdom of the older man's advice, but made it clear that he was restless for change. Steichen made no promises, but the two kept in contact over the next few months. In early 1948, Page did historical research at Steichen's request, tracking down early photographs of the California gold fields. With additional communication, the link between the two was further strengthened.

In the fall of 1948, Page moved from Berkeley to New York. He traveled alone, with the understanding that his wife and young daughter would follow once he had established himself. He took a small apartment on West Twenty-eighth Street and, in October, began working part-time for Steichen as an exhibition assistant at the museum. The project then in the works was "The Exact Instant," a sweeping, three-hundred print survey of the history of news photography scheduled to open in early 1949. Page quickly fell into the frenetic pace of work at the museum, assisting with a wide variety of tasks. He also found time to take an occasional freelance assignment, to see significant exhibitions elsewhere in the city (at the Photo League, for example), and to prowl the streets with his camera.[37]

In late January 1949, Christina and Saaren joined Page in New York. They found a tenement apartment on West 49th Street, near Ninth Avenue, and began an uncertain new life. They were living almost hand-to-mouth, in a veritable slum, but it was an adventure. Page continued his work at the Museum of Modern Art. Christina's various jobs in this period included assisting the writer George Kirstein (the brother of arts impresario Lincoln Kirstein) in offices on Wall Street and across from the Metropolitan Museum of Art on Fifth Avenue. After each day at their respective jobs, the two came home to a grimy apartment with thin walls, paint peeling off the ceiling, a cheap metal kitchen table, and battered old chairs. They came to appreciate the late nineteenth-century reform photographs of Jacob Riis—which featured prominently in "The Exact Instant"—in a distinctly personal way.[38]

Page's life in New York was enlivened by his friendship with Betty Chamberlain, director of publicity at the Museum of Modern Art. Chamberlain was an independent, opinionated, and generous spirit. After graduating from Smith College, she had lived in Paris for a few years. In New York, before starting at the museum, she had worked at Time, Inc., with Whittaker Chambers and James Agee, and had become friends with artists such as Ben Shahn. Despite her prestigious position at the Museum of Modern Art, Chamberlain had little patience for social niceties. As Christina Gardner recalls, "she often dressed in downright shabby clothes and totally refused to wear stockings, deeming them an unnecessary extravagance and a symbol of the subjugation of women."[39] Chamberlain loved to socialize and seemed to know everyone in the city. She helped Page and Christina get their bearings, and she became his lifelong friend.

Page settled into this new rhythm of life with hopeful anticipation, awaiting word from the John Simon Guggenheim Memorial Foundation. The winning of a Guggenheim Fellowship had become something of a Holy Grail for him since Lange had planted the idea some time earlier. The concept of being paid to pursue his own vision, unfettered by other constraints or obligations, was enticing beyond words. The Guggenheim represented both a year's financial freedom and the most prestigious kind of professional recognition.

The John Simon Guggenheim Memorial Foundation was established in 1925 by Simon Guggenheim in honor of a son who had died in 1922. Fifteen fellowships were granted that first year, but the number of recipients increased markedly in succeeding award cycles. In 1937, after a dozen years of supporting scientists, poets, composers, painters, and writers, the Guggenheim Foundation first recognized photography when it gave Edward Weston a $2,500 grant (renewed in 1938) for his project "California and the West." This represented an important milestone in the history of creative photography. Walker Evans was the second photographer to be so honored, in 1940, followed by Dorothea Lange and Eliot Porter in 1941. By the time of Page's application, fellowships had also been granted to photographers Wright Morris (1942), Jack Delano (1945), Brett Weston (1945), Ansel Adams (1946), G. E. Kidder Smith (1946), Wayne Miller (1946), and James A. Fitzsimmons (1948), as well as to curator and historian Beaumont Newhall (1947).

Page submitted his Guggenheim application on November 1, 1948. He had the strongest possible references: Lange, Taylor, Steichen, and Beaumont Newhall (in his new position as curator of the George Eastman House, in Rochester). Not surprisingly, these references emphasized

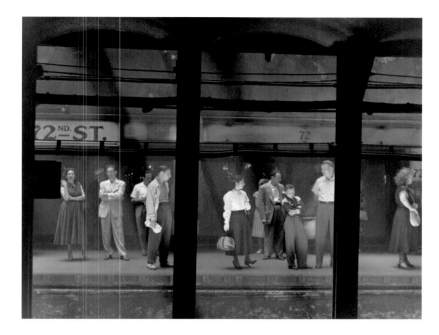

FIG. 13 *New York*, July 23, 1949

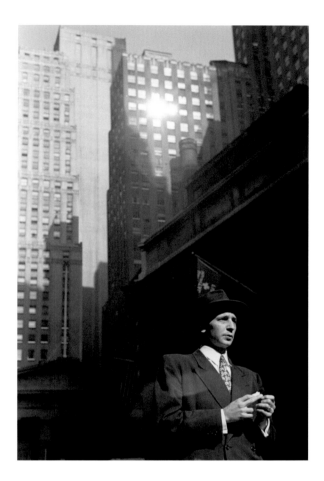

FIG. 14 *New York*, October 21, 1949

different virtues in the young photographer. Steichen observed that "Homer Page is one of several photographers who are interested in the use of photography in relation to the printed page of a book." He compared Page favorably to Wright Morris, whose recent publications *The Inhabitants* (1946) and *The Home Place* (1948) provided a much-discussed model for the effective union of photographs and text. Lange, on the other hand, emphasized Page's "keen and intense perceptions," noting that "he lives on the edges and boundaries and goes into unfamiliar territory…"[40]

Page's Guggenheim statement [APPENDIX C] is revealing—at once admirably clear and dauntingly ambitious. He stated that he had been working for four years on "a photographic inquiry into city life." By the time of his application, this had evolved into a two-step process: "to photograph the qualities of the relationship between urban people and the cultural forces which surround them," and to organize the resulting images into a meaningful sequence, in the form of a photographic book.

These objectives represented a clear continuation of ideas Page had been grappling with since 1944. Page acknowledged a fundamental social dynamic: on one hand, the pervasive power of shared beliefs and standards of behavior; on the other, the myriad ways these impersonal

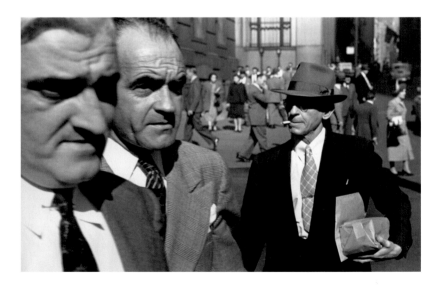

FIG. 15 *New York (Wall Street)*, October 21, 1949

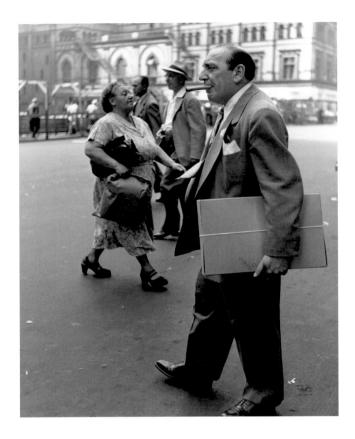

FIG. 16 *New York,* June 28, 1949

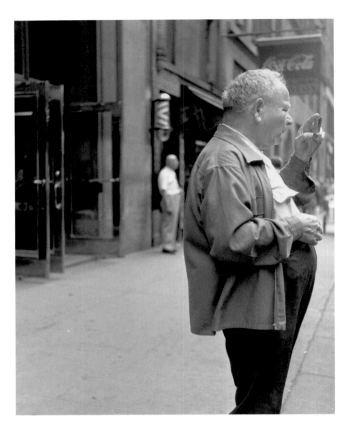

FIG. 17 *New York,* June 28, 1949

strictures were embodied in the actions and attitudes of real people. He aimed, he said, to photograph those points "where our requirements as human beings and the demands of our culture meet." Page knew that his challenge lay in giving compelling visual form—and the quality of a genuinely singular perception—to these rather abstract concepts.

Page saw this problem as a central one for photographers of the day. He sought to forge a new and more complex union of seeing, understanding, and expression: to use the camera not merely as a descriptive tool, but as a means of cultural understanding and interpretation. In his words:

> The use of photographs to communicate knowledge and ideas is of growing importance. It is a curious fact, however, that in spite of enormous strides taken in many parts of this field, only a few efforts have been made to mold and unify individual photographs into a complete form of expression. Such a form must be forthcoming if the photographer is to be accepted as a person capable of making a full statement about what he sees and feels. Otherwise, he will remain in the position of being able to show only disjointed fragments of his total concept.

In Page's view, serious photographers needed to understand their work as a "complete form of expression," the articulation of a "total concept."

After weeks of anticipation, Page's letter of congratulations arrived on April 7. For his one-year appointment as a Guggenheim Fellow, to begin April 15, he would receive $2,500. At his request, this was increased to $3,000, a welcome but not lavish sum. Christina continued to work throughout the fellowship year and (with the approval of the Guggenheim Foundation) Page accepted a few freelance assignments. Nevertheless, the fellowship represented a dream come true. Page began by setting up a good darkroom in the kitchen of their apartment. He also supplemented his trusty Rolleiflex with a fine used 35mm Leica rangefinder, the best "miniature" camera of its day.

Page made the first of his Guggenheim photographs on April 26, in the course of a lengthy walk through the heart of Manhattan, from Washington Square to Eighty-fourth Street, recording people on the sidewalk and in Central Park. On the next two days, he worked primarily along Broadway. On April 29, he photographed a labor rally with demonstrators holding signs reading "End Jim Crow in Industry" and "Repeal

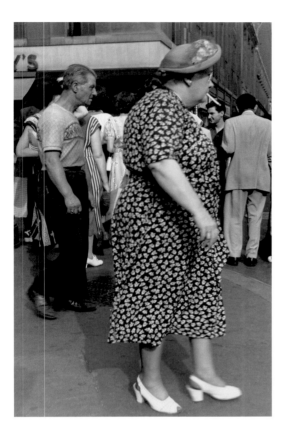

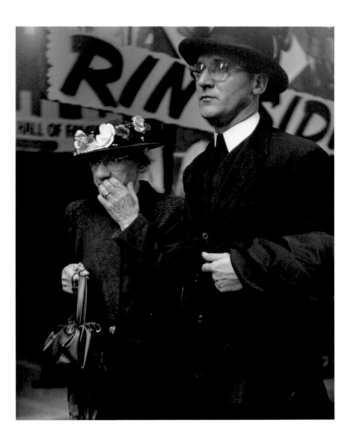

FIG. 18 *New York,* July 22, 1949

FIG. 19 *New York,* September 16, 1949

the Taft-Hartley Law." Beginning in this first week, Page began dating each day's work by using the first frame of his roll to record the front page of the morning's *New York Times.* In addition to providing a definitive "time stamp" for the day's pictures, this practice underscores Page's instinctive awareness of the leading news stories of the time.

After his joy at receiving the Guggenheim Fellowship, the work itself put Page on an emotional roller coaster. He worked hard in the first few weeks, but was dissatisfied with his results. It took more effort than he had expected to master his new Leica, and he was unhappy with his pictures. On May 2, he wrote Lange, "two weeks have now gone . . . and there isn't much to show for it."[41] By May 26, he was feeling even worse about his results: "the first month of work has been a fiasco and very disappointing."[42]

In truth, this rocky start was probably inevitable. Page had placed all his personal and professional bets on the Guggenheim Fellowship. He had asked for the time and money to do something important and he now felt enormous pressure to prove himself. Before that could be done, however, he had to resolve some old methodological issues.

These included the fundamental tension between the demands of fact-gathering and self-expression, the guiding logic of preconceived ideas versus a more visceral approach to picture making.

Page spent the next few months working through these issues. Lange had urged him to document his images precisely, by making detailed notes on the circumstances of each group of shots. Page understood the value of this information, but finally admitted that he couldn't do it. The note-taking process took too much time and broke his concentration on the more important act of seeing.[43] On a larger level, Page was forced to be more realistic about his conceptual ambitions. Knowing full well that no photographer could ever exhaust a subject as vast as modern American urban culture, Page had nonetheless hoped to create something approaching an encyclopedic visual inventory of iconic types, situations, and forces.[44] However, as he observed in a letter of May 2:

> The main job right now is to attempt to cut the subject down to a workable size. It is altogether too large to hold easily in the mind, and thus be able to handle it well while operating. Some days, everything I see seems to be important; other days, nothing. Since I have no success in visualizing images

of importance and then going out and getting them, I must get my ideas in easily manageable form and carry them with me when I work.[45]

After more intensive thought on the matter, Page wrote to Lange on May 26:

The main difficulty, of course, is getting close to my subject. So much thought has gone into it that these very thoughts get in my way when shooting. When I get to work again, I plan to forsake my thoughts and react only to what feels right to me and my camera. Steichen says to "get drunk photographing," which is quite right . . .

I find a great gap between what I thought important to photograph and what [I] see when I get to work. It is of course the old difficulty of finding the universal while looking at the specific. There is so much to be said for the reality which you see with your own eyes. It is, after all is through, the only truth to rely on; it is the proof or disproof of your ideas, and it must take precedence over such ideas. But at the same time, I think it is all too easy to become lost in the richness and confusion of what you see. To develop a seeing which is humble before the flow of life and yet capable of extracting a meaning from it—this is a life's work. It is, I think, a question of delicate balance, to know when to receive and when to impose; when to act as a vehicle and when an interpreter.

As you know, I have never accepted the idea that a photographer can make truly objective observations, he is too much involved with what he photographs. But he most certainly has the obligation to get what he sees is true whether he likes it or not. What bothers me is this gap between ideas and reality, and the precarious bond between them. It is true that you can't photograph directly from principle, yet you can't photograph directly from experience either. How much of each?[46]

After several months of effort, Page was finally able to work through these issues. He remained a rigorous critic of his work, holding himself to the highest of standards. But he recognized that his vision was changing as a result of having found a new, more satisfying balance of concept and perception.

At the six-month mark of his fellowship tenure, Page evaluated what he had accomplished. On October 3, he wrote Lange:

This week end, I faced the truly formidable task of summing up the first half year (realizing that that much time is gone is itself a great shock). The results of this review leave me in alternate states of elation and depression. Sometimes, looking at the best work, I feel that there is something of the life in it. At other times, it is flat, terribly flat, and a poor show for the time and energy spent.

There are a little over 500 prints in the file. About 300 of these are of some possible use, the other 200 are worthless. Of the former, there are about 60 (only 10 a month!) which you can call photographs . . .

I find myself using the Leica now almost exclusively, except for flash and special jobs. Most of the prints I send [to you] are Leica all printed in the full negative. You will notice that my seeing is changing, and tho I have little alternative but to follow my eye, I wonder what you think about it. It has seemed to me that I have purified the image too much previously, selecting out too much of the confusing elements of the scene and leaving the picture without much breath and blood. The newer images more suit my ambivalent and confused state of mind.[47]

In an undated letter to Lange of this same period, Page underscored these sentiments:

The work here creeps forward . . . The inadequacy of the photographs to show the richness of this life is a thing I cannot avoid. They are truly such pale reflections. And in spite of some 4 or 5 hundred photographs in the file, they constitute such a meager coverage of city life. All this I know is inevitable, but it is nevertheless gloomy.

The way I see things seems to be changing. The prints are freer in construction, yet more complex. In this chaotic world here, I am unable to achieve the purity and simplicity of form which I once aspired to. This new seeing is exciting tho, and I think closer to an accurate record of this life.[48]

By this time, Page's harsh evaluation of his work had become a natural reflex. He had a sharp eye for weakness and failure—in himself and in others. As a result, self-criticism came easily to him. In addition, his comments to Lange must be understood in the context of their "master/apprentice" relationship. With the deepest understanding of Lange's high stature and standards, Page could only be modest in discussing his own work.

Thus, in taking Page's words at face value, it is important to focus on his excitement about "this new seeing." Halfway through his fellowship year, it is clear that he had come to a new understanding of his work. While distressed by his boxes of less-than-remarkable images, Page took real pride in the growing number of successful ones. His technical mastery and visual instincts had been refined and enlarged. In addition, his appreciation for pictorial construction had changed. Previously, he had aimed for a certain clarity and simplicity of form. Now, he sought to make looser and more dynamic pictures—images with the complexity and ambivalence, the "breath and blood," of New York itself. For about a year, Page had been exploring the concept of "absolute" versus "relative" images [APPENDIX B]. He used the first term to describe photographs with relatively simple, centralized subjects; the second referred to those with richer, denser networks of formal

connections. In Page's terminology, "absolute" images dealt primarily with things, while "relative" ones pointed to relationships.

Page responded to New York in two ways: through both his mode of vision and his choice of subjects. From the day of his first walk from Washington Square to Eighty-fourth Street, Page's view of New York was that of an ordinary man on the street. He focused on everyday activities in the city's most public spaces. He sought the tell-tale moments, connections, or juxtapositions that were so common as to be essentially invisible to casual eyes. The vitality and sheer visual density of this environment demanded a corresponding visual style, one that matched his emotional response to the place.

He applied this vision to a wide variety of subjects. He began with the rich theater of the street itself: the flux and flow of pedestrians in motion, friends and family members conversing, children playing, political rallies and protests, isolated figures resting and watching. Surrounding this human activity was an inanimate backdrop of objects, signs, and symbols—buildings, vehicles, product displays and advertising, graffiti and detritus. Page's holistic view encompassed both the inhabitants of the city and their physical traces and artifacts. As the city's quintessentially public space, the street forms the central thread of Page's exploration. A rich subject in itself, the street serves as the implicit link to his various other motifs.

The basic visual themes of Page's Guggenheim work were drawn directly from the social sciences of the day. He was interested in the texture of everyday experience: how people lived, interacted with one another, and relaxed. He was intrigued by the discrete "realms" of modern society: the differing worlds of men, women, and children, and of whites and blacks; the distinctions between rich, middle class, and poor; and the varieties of gainful employment, from white-collar office jobs to street labor. He recognized that every individual inhabits both an objective public domain and a deeply subjective sphere of thought and emotion. He was concerned with the power of the mass media—advertising, the press, movies, and television—to shape ideas and attitudes. He was fascinated by the American culture of consumption: the seemingly endless cornucopia of goods on display, the appeal of novelty and fashion, and the power of advertising. He observed the human effects of this new mass, technological, and bureaucratic society—the mixed blessing of comfort and conformity that it represented. Ultimately, he was concerned with the fundamental quality of his culture and with what it meant to be an American.

THE TEMPER OF THE TIME

These interests placed Page in full sympathy with the ideas of leading artists and intellectuals. For many, the postwar years represented "The Age of Anxiety"—the title of W. H. Auden's lengthy poem that received a Pulitzer Prize in 1948.[49] This poem also inspired a symphony by Leonard Bernstein, which made its New York premier on April 8, 1949, and a 1950 ballet by Jerome Robbins. On a political level, this period saw the birth of the cold war, the Red Scare, and the terrible threat of nuclear annihilation.[50] It is significant, for example, that Page's photograph *Two Days of Protest* [PL. 27] records the aftermath of a public demonstration over the jailing of three defendants in a Communist conspiracy trial.[51] Only a few months later, in a span of eight days, the American public learned (on September 23, 1949) that the Soviets had successfully tested their own atomic bomb and (on October 1) that China had fallen to the Communists. The years that followed saw increasing tensions between the rival powers, an escalating arms race, and the fear and paranoia of Senator Joseph McCarthy's anti-Communist crusade.

At the time, everyone knew that American society was changing rapidly—but whether the changes were for good or ill was unclear. The patriotism, frugality, and self-sacrifice of the Depression and war years had—it seemed—given way almost overnight to a hard new world of skepticism, insularity, and empty consumerism. There seemed to be a curious dichotomy in American culture: tremendous new energies and opportunities, as well as an increasing sense of anonymity and disillusionment. These ideas were expressed in the arts, in part, in a new sense of rawness and vitality—in the muscular immediacy of Abstract Expressionist painting, the nervous rhythms of Be-Bop jazz, and the violent, shadowy world of pulp detective fiction and film noir.[52] The problem of mass culture preoccupied American intellectuals in the postwar years. Many critics decried the dismal quality of popular entertainment and the growing homogenization of American thought and experience.[53]

The key terms of this period include "identity," "conformity," "alienation," and "malaise." Arthur Miller's award-winning play *Death of a Salesman* opened on Broadway on February 10, 1949. It conveyed a growing fear of the day: losing one's soul to a deadening, meaningless job. Two important sociological texts of this period investigated these concerns at length. David Riesman's *The Lonely Crowd: A Study of the Changing American Character* (1950) described the psychological effects of the new conformism of American society. Riesman asserted that a

characteristic new psychological type, which he termed the "other-directed" personality, was shaped by the pressures and expectations of one's peers. Conformist by nature, "other-directed" personalities functioned well in bureaucratic organizations, but had a diminished sense of individual identity. Similarly, C. Wright Mills's *White Collar: The American Middle Classes* (1951) examined a vast new class of American workers, a culture of salesmanship and clean-cut regimentation. Paralleling these sociological concerns was an intellectual vogue for the psychological writings of Sigmund Freud, and for the philosophy of Soren Kierkegaard and the burgeoning movement of existentialism.[54]

This new focus on identity reflected the changing dynamics of American society.[55] In the coming years, the roles of women, African Americans, and adolescents would all evolve markedly. Modern feminism may be said to have begun with Simone de Beauvoir's book, *The Second Sex*, published in France in 1949 and the United States in 1953. The presence of women in the working world was growing slowly but steadily in this period, and their roles at home were beginning to be examined critically.[56] The great project of African American civil rights gained momentum in the postwar years—in the writings of James Baldwin and Ralph Ellison, in legal rulings such as *Brown v. Board of Education of Topeka* (1954), and in myriad other actions and events. Youth culture took on unprecedented importance in the postwar years. For the first time, teenagers formed a discrete segment of American society, with their own attitudes and tastes.

These ideas—and many more—were in the air as Page walked the streets of New York with his camera. On some level, he was aware of nearly all of them. However, he also valued an important lesson of Dorothea Lange's: to resist the temptation to reduce actual people merely to social "types" or representative examples. Typological thinking led, inevitably, to cliché and caricature. Instead, Page aimed to suggest the significance of these larger ideas and forces through the evidence of real people and real events. He was concerned with the way these abstract ideas shaped—and were shaped by—actual lives.

In this quest, the street itself played a critical and central role. The street was at once spectacle and stimulus, an ever-changing kaleidoscope of activity and a source of creative inspiration. Charles Baudelaire had written nearly a century earlier of the pleasures of the strolling urban observer:

> For the perfect flâneur, for the passionate spectator, it is an immense joy to set up house in the heart of the multitude, amid the ebb and flow of movement, in the midst of the fugitive and infinite. To be away from home and

yet to feel oneself everywhere at home; to see the world, to be at the center of the world, and yet to remain hidden from the world . . . the lover of universal life enters into the crowd as though it were an immense reservoir of electrical energy.[57]

For Baudelaire, the key words were:

> Multitude, solitude: equal and convertible terms for the active and fecund poet . . . The poet enjoys the incomparable privilege of being able as he likes to be himself and others . . . The solitary and pensive walker draws from this universal communion a singular sense of intoxication.[58]

In the mid-twentieth century, the experience of the busy city street triggered both a sense of universal kinship and feelings of psychological unease. In many respects, the street was the province of strangers—an endless stream of "others" one brushed past but did not know. This duality of physical proximity and emotional distance was paralleled by a new sense of the complexity and fragility of the individual ego. The "intoxication" of city life could, variously, either expand or diminish one's sense of self. The dense urban population symbolized both the power of humanity *en-masse* and a characteristically modern sense of vulnerability, loneliness, and isolation. Intuitively, artists understood that the complexities of the city street echoed the state of the individual soul. It was, therefore, two sides of the same coin to seek to understand society and the self, the universal and the personal.

Page's stated subject was the complex character of American society—as revealed through the example of countless individual Americans. Appropriately, he made a point to photograph the city's tenth annual "I Am an American Day" in Central Park.[59] Nearly one hundred thousand people attended this event to listen to a band concert and addresses by Mayor William O'Dwyer and other dignitaries. A federal judge then administered a mass oath of allegiance, commemorating the fact that twenty thousand of those in attendance had become naturalized citizens in the previous year. Tellingly, Page's photograph [PL. 1] focused on the variety of these faces and on the crowd's restless inactivity. These proud new Americans are squeezed together, in organized rows, yet most appear lost in their own mental domains. They are united by proximity, but the collective meaning of their citizenship remains ambiguous.

It was exactly that larger sense of cultural identity that Page explored in his walks in and around New York. He was fascinated by the business world and the endlessly repeated cycle of the working day. He recorded commuters going to and from work, standing sleepily on subway cars and walking in lockstep through the canyons of lower Manhattan [FIGS. 13, 14; PLS. 2–5]. After the morning flood of commuters, the sidewalks

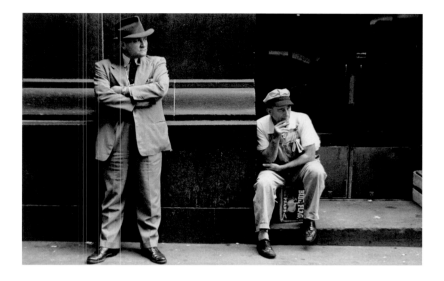

FIG. 20 *New York*, September 16, 1949

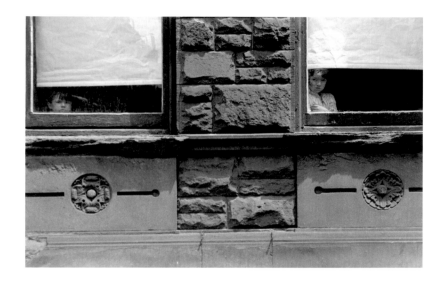

FIG. 22 *New York*, May 28, 1949

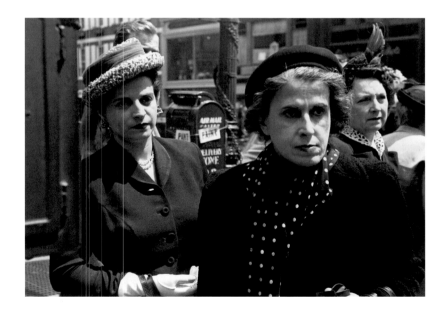

FIG. 21 *New York*, May 7, 1949

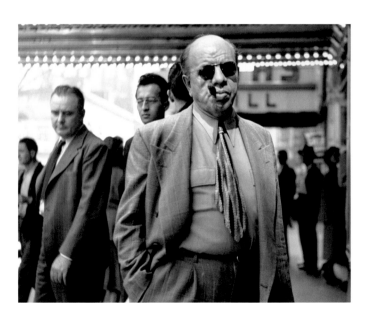

FIG. 23 *New York*, September 16, 1949

were alive with another kind of traffic: a diverse mix of business people, shoppers, and kids. Page loved the visual energy of these crowded thoroughfares: several of his photographs focus directly on this sense of flux and contingency [FIG. 15; PLS. 6, 8].

In addition to these views of crowds, Page looked intently at individuals—male and female, young and old [FIGS. 16–19]. He was enthralled by the details of clothing, stance, and gesture. No two of these people were truly alike, and something of their individual lives was revealed in their attire, expressions, and body language. From a slight, diffident socialite in a fur stole [PL. 11] to a broad-shouldered African American laborer [PL. 37], Page assembled a visual catalogue of memorable figures. All are distinctly individual; together they suggest something of the texture of American urban life.

Significantly, many of these images record people in the act of looking [FIGS. 20, 21]. By bearing witness to these acts of observation, Page emphasized the city as an endlessly rich source of visual experience. Included in this notion are Page's records of vernacular photographic practice [PLS. 30, 31], and those images in which his subjects look directly back at him at the moment of exposure [FIGS. 22, 23; PLS. 13, 15]. Implicitly, Page's photographs assume a stance of self-awareness while endorsing the basic wisdom of the eye: the truths (however fleeting and fragmentary) to be gained through looking.

In part, the spectacle of the street was a direct expression of the ethos of the free market and the new wealth of American society. Page was fascinated by emblems and rituals of consumption: the advertising [PLS. 20, 32], display [PL. 17], and sale [PLS. 18, 19] of all manner of goods. He repeatedly photographed shoppers on the street, parcels in hand. He also made several witty images of more vernacular forms of promotion: human "billboards" conversing on the sidewalk [PL. 21], and the juxtaposition of a bust of George Washington with a hand-lettered sign for Navy surplus sunglasses [PL. 22]. Images such as these highlight his attentiveness to the continuous play between commercial culture and a more humble level of vernacular or folk expression.

As an extension of this idea of advertising and consumer culture, Page took considerable interest in the mass media. He photographed people reading newspapers [PL. 24], as well as magazine stands [PLS. 25, 28], a display of paperback books [PL. 26], a portable radio [PL. 53], a television [PL. 70], and numerous movie posters [PLS. 67–69]. Through Page's eyes, this new world of mass-market images and information was a distinctly mixed blessing. An image to which he gave the deliberately ironic title *Public Guardian* [PL. 25] shows a young professional man

lingering at a display of cheap girlie magazines.[60] Similarly, the movie posters he recorded appear to represent uniformly "low-brow" productions: potboilers and thrillers.

The cultural meaning of Page's image of a sidewalk display of paperbacks [PL. 26] is particularly interesting. Pocket books, as they were known at the time, were a relatively recent phenomenon in 1949. Much cheaper (and physically smaller) than traditional cloth-bound books, the paperback changed the nature of both reading and publishing in America. Some saw the pocket book as a democratizing force, expanding the size of the reading public. Others decried the trend toward cheapness and disposability. By the nature of the business, paperbacks tended to fall into two broad categories: "classics" that had fallen out of copyright and could thus be reprinted inexpensively, and new titles geared to a large and relatively undiscriminating readership. As a critic of the time put it, "The tendency of paperback publishing has been to disseminate the best from the past and the most mediocre from the present."[61] Close examination of Page's photograph reveals this to be true. The books on display range from the collected works of Shakespeare and *The Pocket Book of American Poems* to trashy thrillers with titles such as *Bury Me Deep* and *G-String Murders*.

Established publishers felt squeezed by this flood of inexpensive books. The popularity of paperbacks cut into the sales of more serious volumes, which, by comparison, were relatively expensive and risky business propositions. As a result, there were concerns that paperbacks would not simply enlarge the reading public, but also degrade the quality of the literary marketplace. Thus, Page's photograph represented much more than a simple inventory of titles. It suggested a powerful dynamic in American cultural life: the tension between "high-brow" and "low-brow" tastes, the tug-of-war between economic and aesthetic values.

As a logical part of his interest in mass culture, Page turned his camera on a host of popular amusements and recreations. He photographed visitors to Coney Island [FIG. 24; PLS. 48, 49], as well as people at baseball games [FIG. 25; PLS. 50, 53], at the horse track [PLS. 51, 52], and at boxing matches and Roller Derby contests. In these settings, Page focused almost exclusively on the spectators, rather than on the action they had come to see. He also recorded more impromptu amusements in nightclubs, at street carnivals [PL. 71], and on New Year's Eve [PL. 72]. In all these situations, he was interested in the play between individual identity and the collective behavior of the crowd.

Page was also attentive to the various facets of American society: rich, working class, and poor; white and black; young and old. His street

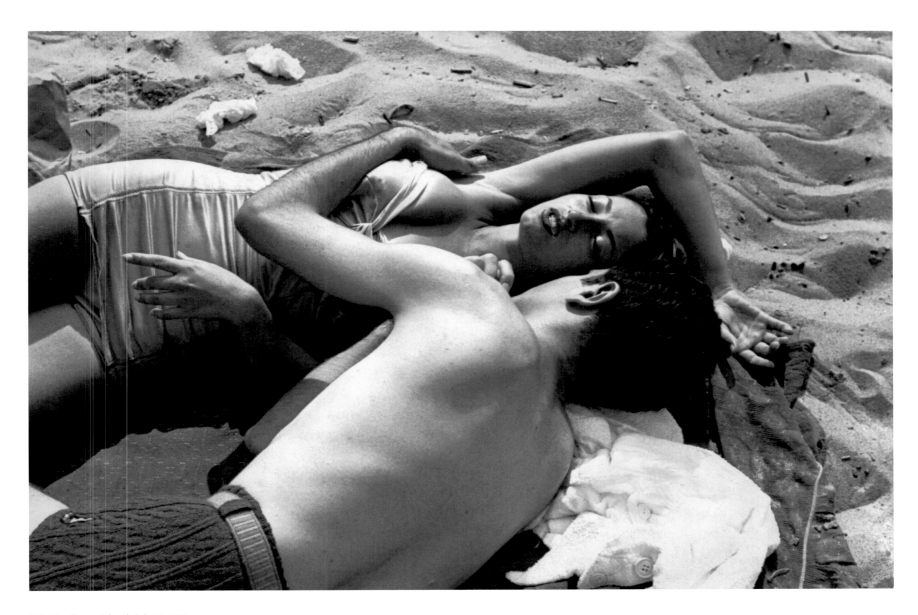

FIG. 24 *Coney Island*, July 30, 1949

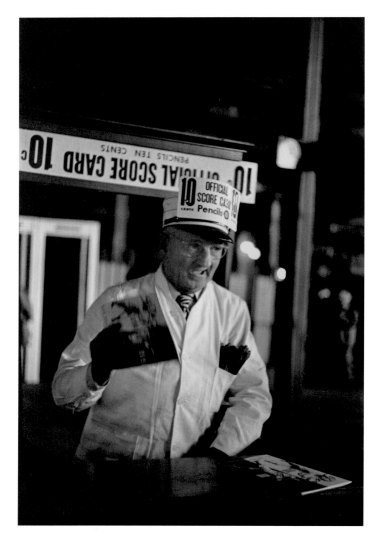

FIG. 25 *New York,* September 16, 1949

pictures capture business executives and manual laborers; professional women and mothers with children; street vendors and the homeless. He portrayed African Americans subjects as everyday, middle-class citizens: a reserved, well-dressed young couple [PL. 35], muscular blue-collar workers [PLS. 37, 39], and a cautious visitor at the beach [PL. 48]. Similarly, several of his group shots [PLS. 1, 4, 14] present a quiet but pointed vision of social integration.

He also recorded the least savory aspects of urban life: a decrepit men's room [FIG. 26] and those without home or hope [PLS. 56, 58]. Notably, these latter photographs avoid the revelation of personal identity, serving instead as examples of a social type or category. This was appropriate in at least two ways: as a sign of respect for the utter vulnerability of these men, and as an acknowledgment that this state of existence contributed to a diminishment of unique, innate character.

In his attempt at a broad view of the urban scene, Page also moved beyond the city street to capture a variety of other subjects. He worked indoors, documenting office workers [PL. 16]; women at a hairdressing salon and a laundromat; various sections of a large department store; dancers and actors in rehearsal; and classrooms at a grade school [FIG. 27], a business school, and a fashion institute. He even made a trip out to Levittown, Long Island, to photograph the area's famous new suburb [PL. 63]. Begun in 1947, Levittown was the nation's first mass-produced suburban development. A powerful symbol of the new social and economic forces at work in American culture, it served as a model for the growth of suburbs nationwide in the following years. Page's photograph is ironically deadpan, suggesting both perfection and sterility, utopia and purgatory.

Page's photographs evoke a characteristic quality of mood and emotion. In his "What Is Modern Photography?" comments, Page acknowledged the validity of two key approaches to "documentary" or "street" photography: on one hand, a humane, objective, and affirmative outlook; on the other, a more subjective vision of mystery, complexity, and critique. Page typically operated midway between these poles. His photographs are deliberate, but far from emotionless; they are rich with information, but never simply anecdotal. We sense his interest, curiosity, and sympathy in each carefully considered frame.

Page often worked at fairly close range to his subjects. At this distance, even the slightest figures tend to be elevated or enlarged by his lens. We know that he was interested in these people as artistic subjects; we can also sense his respect for them as fellow citizens. While Page would never have denied that he felt more connection to blue-

collar workers than to corporate executives, his vision is founded on a fundamental quality of acceptance and respect. He could be sardonic, but not sarcastic. While his vision tends toward the bittersweet, it is never merely bitter.

These images are characterized by a rich sense of inwardness. Page was a deeply thoughtful photographer, and the motif of being "lost in thought" is central to his work. With some consistency, his images suggest a state of reverie: an internal condition of reflection, or the quality of being momentarily taken "out of oneself" by the faculty of vision. In this way, perception and emotion, seeing and thinking, are inextricably linked. Page instinctively thought *through* his camera and was drawn to this basic notion of subjectivity and contemplation in the people he photographed.

Page's emphasis on thoughtful subjects only encourages our own process of rumination. One of his key Guggenheim photographs [PL. 2] depicts a businessman on the sidewalk. This image evokes the notion of the "Empire City," a great center of enterprise and achievement. The picture presents curious visual correspondences: the form of the man's upturned head is echoed subtly in both the undulations of the foreground lamppost and in the geometric planes of the background office tower. The building itself—dissolving in the brilliant morning light— seems more ideal than real. At the center of this image, the man is poised in mid-stride, attentive but uncertain, without a clear sense of direction. Whatever has caught him in this instant—a vision or an idea—remains his alone.

Another image [PL. 32] presents a collage of visual fragments: advertising posters, a metal trash bin, an elderly male pedestrian, the top of someone's head. The pedestrian appears stationary between images of legs and canned goods. The ad for nylons emphasizes the seduction of the visual: the perfect legs in the center are being viewed, with envy and voyeuristic desire, respectively, by two women and a man. The advertising copy reads: "One woman tells another . . . men see for themselves." The ad suggests the banality of vision without thought, while the standing man appears thoughtful but oblivious to his surroundings. Page's photograph is pure contingency—overlapping fragments of things, images, words, and figures. Nothing is represented completely, yet the result is a brilliantly resolved pictorial statement that finds form in confusion and meaning in the haphazard.

Yet another photograph [PL. 40] plays with a series of dualities. Here, a young girl watches a mundane if necessary job: the unloading of coal. The scene is dark and gritty, from the sooty delivery truck, to the wall

against which the girl leans, to the coal-strewn sidewalk. The coal—of and from the earth—is here being channeled back underground to a basement furnace. By contrast, the girl provides an almost ethereal note: a rumpled, streetwise tenement angel. She is curious, but wary— standing just out of danger to watch the black fragments tumble by. We are presented with a memorable set of dualities: darkness and light, weight and delicacy, the depths of geological time and the serendipitous pleasure of the fleeting moment. Page's photograph finds an artistic epiphany in a most unlikely place: a small hint of transcendence in the delivery of a ton of coal.

The importance of Page's New York photographs is underscored by the fact that he did not work in a vacuum. Widely recognized as a key symbol of the changing American character, New York was recorded by a host of talented photographers.[62] Prior to Page's arrival in 1948, Helen Levitt, Sid Grossman, Morris Engel, Lisette Model, Todd Webb, and others had already made distinctive bodies of work in the city. Photographing at about the same time as Page, another group—including Louis Faurer, Ted Croner, Saul Leiter, Dan Weiner, and David Vestal— also made important and memorable images. More great work appeared in the next few years, by artists as varied as Leon Levinstein, Louis Stettner, Roy DeCarava, William Klein, Robert Frank, and Garry Winogrand. All these photographers were inspired by the city's vast energy and diversity, and all produced powerful and original images.

Page's achievement bears comparison to the finest work of his time. For example, his eye for the spontaneity of street life may be understood as an extension of the work of photographers such as Levitt and Grossman. At the same time, some of his images boldly anticipate the later visions of Frank and Winogrand. These visual and stylistic connections—both backward and forward in time—only underscore the importance of Page's achievement. He understood the value of existing approaches while anticipating the key creative concerns of the generation to come.

A large measure of Page's originality stems from this very quality of synthesis and integration. He was interested in both sociology and art, the reality of objective fact and the power of subjective perception, the joys as well as the dilemmas of contemporary life. Although he was deeply dedicated to his craft, he remained concerned about a host of issues outside the realm of photographic art.

In one of his letters of this period to Dorothea Lange, Page wrote of "the documentary idea which we worry so much about."[63] Having inherited this concern from Lange, Page was driven by it. Significantly,

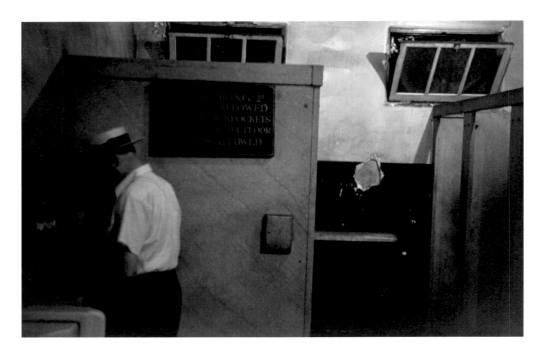

FIG. 26 *New York*, August 25, 1949

he used the term "documentary" in a broader and richer way than was then (or now) generally understood. As would be expected, the term indicated a devotion to the realities of contemporary society—in Edward Steichen's phrase, "what we are like and how we live." It also included the recognition that every "documentary" photograph is fundamentally a *picture*, a created visual artifact, and that some pictures are inherently more compelling and satisfying than others. Thus, this "documentary idea" began with the physical reality of one's subject, but could only end with the aesthetic reality of the image. By necessity, this process of interpretation and translation depended on the attitudes, choices, and opinions of the photographer. There was no sense here of a disinterested claim to objectivity. What mattered was personal: an informed and distinctly individual sense of selection and interpretation. At root, the "documentary idea" was about human facts: the truths of contemporary lives, and an honest acknowledgment of the photographer's own subjectivity. It involved not just the outward facts of contemporary existence, but their inward meaning: a collective state of mind.

In May 1949, at the beginning of his Guggenheim work, Page lectured on documentary practice at the Photo League [APPENDIX D]. Citing "the present confusion of facts and values," he observed:

We are not sure of war or peace, prosperity or recession; not sure what balance to strike between our freedom and our security, either as a nation or as individuals. The fundamental issues are clouded and almost certainly in transition. This makes any attempt to record conditions extremely difficult. This also makes it difficult for any pervasive documentary movement to find common footing, since such movements in the past have generated from relatively clear-cut situations such as war or depression.

However, he suggested, it was precisely this state of psychological uncertainty that demanded recording: "If confusion of values is an important part of our life today, we must analyze and record this confusion." To this end, he advocated new frames of reference, turning from the traditional documentary emphasis on specific places or socio-economic groups toward an embrace of larger and more abstract realities: "the rising tempo of living in cities, shifting family and marriage relationships, present standards of success (and failure), increasing standardization of food, clothes, recreation, news, etc."[64]

Page's ambitions were enormously high. Interested in myriad facets of modern society, he sought above all to explore the psychological tenor of his time. This was a deeply subjective matter: what it felt like to live at that time and in that place. He faced a profound challenge: how to give visual form to something as abstract as a general "confusion of values." However, Page not only understood the problem clearly, he

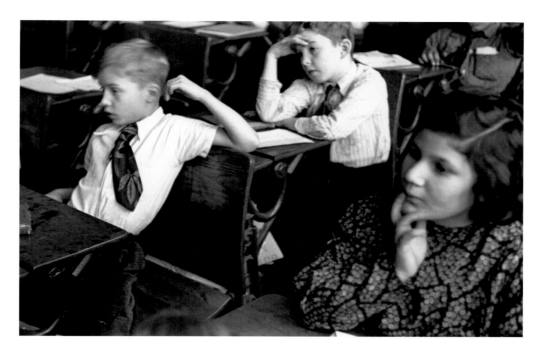

FIG. 27 *New York*, November 1, 1949

succeeded brilliantly in casting it into memorable photographs. His study of New York combines sociological inquiry with poetic reverie. He aimed to encompass multiple facets of modern urban experience, while knowingly centering on only one: his own curious, probing, and generous sensibility.

Page walked a fine line in his Guggenheim work: balancing the demands of fact and interpretation, of world and psyche. The best photographers before him tended to emphasize one aspect of these virtues; the best ones to come typically favored the other. Page stood at a pivotal point in this great stylistic evolution, fully aware of the value of both approaches. In seeking to unite them, he hoped to harmonize the projects of cultural analysis and art, the understanding of both society and the self. Page's work constitutes a remarkable, and even heroic, effort to realize this daunting goal.

LATER LIFE

Page's Guggenheim year ended in disappointment. In the final weeks of his fellowship, he applied for a second year of support but was turned down. His marriage, which had been unraveling for some time, finally came apart. Christina moved back to California with their daughter,

and the couple officially divorced in 1953. Friends noticed that Page was drinking more than before.

Amid this emotional turmoil, Page struggled to finish his New York book. He created at least one mock-up, which he showed to several publishers. None of them leapt at the opportunity to take it on, however, and Page could not publish it himself. Almost immediately, he became fully occupied with the challenge of earning a living. As a result, he put his precious Guggenheim prints into storage boxes, where they remained—essentially untouched—for the next half century. One gets the feeling that Page considered it undignified to have to persuade others of the importance of this work. He knew how significant it was, and on some level that was enough. In truth, these prints contained so much of himself that he may have been reluctant to let them out of his hands. His Guggenheim work was far more than "just" another project: it was the most difficult thing he had ever done—and the best.

Page went on to a varied and successful post-Guggenheim career. For a few years, this included a continued engagement with the fine-art photography world. In 1953, for example, he was featured in a prestigious group exhibition, "The West," at the Colorado Springs Fine Art Center, and his photographs were also included in a major group exhibition at the National Museum of Modern Art in Tokyo.[65] He continued his part-time work at the Museum of Modern Art in this period, serving as one

of Edward Steichen's chief assistants for the celebrated 1955 exhibition "The Family of Man." Nine of Page's photographs were included in this blockbuster show, which was seen by millions around the globe.

However, for reasons that can only be guessed, this marked the end of Page's regular appearance in a fine-art context. In the 1950s and 1960s, he earned his primary living as a freelance and contract photojournalist. He traveled the world in these years in pursuit of a great variety of subjects. He worked for editors who genuinely appreciated his talent and appears to have had considerable latitude in choosing his assignments. The jobs were never easy, or as regular as he might have liked, but he loved the freedom and the adventure of this life. In truth, he had one career in photography up to 1950, and another one afterwards. This book attempts to do justice only to the first of these periods.

For a short time, Page was part of the legendary Magnum photo agency. Begun in 1947 as a nonprofit photographic cooperative, Magnum was seeking to extend its American coverage in 1950. Page joined the group on July 1, 1950, in something like affiliate status, rather than as a full stockholder and voting member. He paid the substantial sum of $600; in return, the group recommended him for assignments and distributed his pictures for a percentage fee.[66] For a variety of reasons, however, this arrangement proved unsatisfactory. At least three other American photographers—Esther Bubley, Sol Libsohn, and John Collier—held a similar status with Magnum, but none of them lasted long with the group.[67] After carrying out an agency-funded assignment in South Africa, Page and Magnum parted company.[68]

In 1951, Page took a job as picture editor for *Argosy*, a men's magazine edited by Jerry Mason, a friend of both Page's and Steichen's.[69] Page photographed hardworking men for the magazine: miners, lumberjacks, demolition experts, and steelworkers. In subsequent years, he contributed work to other men's magazines, including *Cavalier, Adventure,* and *True*, as well as to a variety of more mainstream publications. Images from his most powerful photo-essay of this period, a sensitive study of Korean War amputees, were published in *Harper's Bazaar* in April 1952, and in the 1953 edition of *U.S. Camera Annual*.

In the next dozen years, Page made many trips overseas. In the early 1950s, he photographed throughout Africa. This work was reproduced in magazines such as *Fortune* and *Jubilee*, and in the Texas Company's 1956 publication *Profile of a Giant*. He also worked closely with the freelance writer Oden Meeker, assisting with the photographic illustrations for Meeker's book *Report on Africa* (1954). In the later 1950s and early 1960s, Page worked in India, Indonesia, Laos, and other Far East

countries. In 1957, for example, he produced a photo-essay on a little-known Catholic nun in the slums of Calcutta named Mother Teresa. Page's work in Laos resulted in a collaborative book, *The Little World of Laos* (1959), with text by Meeker and thirty-seven photographs by Page.

Page also made repeated visits to the Caribbean and to Central America in this period. His special interest in Puerto Rico resulted in several articles on the island nation and the book *Puerto Rico: The Quiet Revolution*. This volume, published by Viking in 1963, presented a broad and sympathetic look at Puerto Rico's history, culture, and economic development. In words and pictures, Page touched on many aspects of the nation, including its geography, agriculture, politics, arts and crafts, industry, housing, health care facilities, and schools.

Beginning in the early 1960s, Page established himself as both a photographer and a writer. For example, both the text and photographs of the Puerto Rico book were his work alone. By this time, it was clear that Page's interests and abilities exceeded the boundaries of standard photojournalistic practice. His passion for social justice and his wide-ranging intellectual curiosity led him to research, write, and sometimes illustrate articles on a wide range of topics. He became a regular contributor to *Think* magazine, a journal of contemporary scientific and social issues published by IBM. Page contributed articles on a host of subjects, including cancer researchers, Alaska, Puerto Rico, nuclear physicists, the training of Peace Corps volunteers, art as investment, and profiles of social scientist and diplomat Ralph J. Bunche and architect Philip Johnson. For other publications, he composed articles or photo-essays on mental health, juvenile delinquency, young civil rights workers in Mississippi, and other subjects. In 1961, he married Marjorie Peterson, who had previously worked for the World Health Organization in Switzerland.[70]

By the mid-1960s, Page had turned from both photographing and writing to writing alone. He took a job with a regular salary—the first such position he had held in decades—as a grant writer for Marts & Lundy, a respected consulting firm to philanthropic and nonprofit organizations. His work included writing grants for universities and other nonprofits.

Spurred by his increasing interest in the natural environment, Page began spending more time away from the city. His old friend Betty Chamberlain had introduced him to Dark Entry Forest, a 750-acre nature preserve cooperative in northwestern Connecticut. He became a member of this cooperative in 1962, taking out a ninety-nine-year lease on a five-acre site in Cornwall, Connecticut. Over several years of weekend and temporary visits, Page built a house of his own design, by

hand. Once it was completed, in about 1967, he and Marjorie made it their exclusive residence.[71]

In this idyllic setting, Page became active in the environmental cause. In 1971, he became associated with the Friends of the Earth Foundation, based in San Francisco. He contributed a regular column, "View from New England," to the group's newsletter, *Not Man Apart*. He wrote on air and water pollution, the controversy over the construction of new roads, local and national environmental legislation, and other topics. In 1972, he edited a special issue of *Not Man Apart* documenting a United Nations conference in Stockholm on the human environment. In addition to editing this issue, he contributed an essay on the ecological effects of the Vietnam War. In 1973, Page also became affiliated with the Conservation Foundation, in Washington, D.C.

As part of a back-to-the-earth simplicity, he ran what he called the Country Workshop in the late 1970s. He earned some extra income by designing and making wooden walking sticks and iron fire tools—pokers, scissors, and shovels. He also sold split-rail fencing and hand-crafted furniture [FIG. 28].

Page lived sparely but well in this period. He spent nearly every day as he chose, removed from the demands and deadlines of the outside world. While he was two hours' drive from New York City, Page did not lack for social or intellectual stimulation. The Cornwall area was home to a lively community of artists and writers, in which he played a central role. In the early 1970s, Page separated from Marjorie and in 1976 began seeing Jeanne Russo, a social worker who shared his interest in progressive political causes and the arts. Russo moved to Cornwall in 1977 and the two were married in an intimate ceremony at the house—officiated by their dear friend Betty Chamberlain, a justice of the peace—in 1980.

As he aged, Page continued to purify and simplify his life. He loved his property—the extraordinary rhythm and variety of life, from sunrise to sunset, season to season, year after year, in his backyard meadow and the surrounding woods. As Jeanne Russo Page recalls, his idea of a good time was to have friends over for a leisurely dinner, spirited conversation, and a reading of poetry. As always, he seemed to be interested in nearly everything. In the arts, for example, he had a particular passion for Etruscan art and the poetry of John Donne. One of his last requests, when he was seriously ill with cancer, was to hear a familiar Donne poem read aloud. Page died at his home on September 7, 1985, at the age of 67.[72]

In describing her husband's character, Jeanne Russo Page observed, "He did not talk much about the past. He always lived in the present."[73]

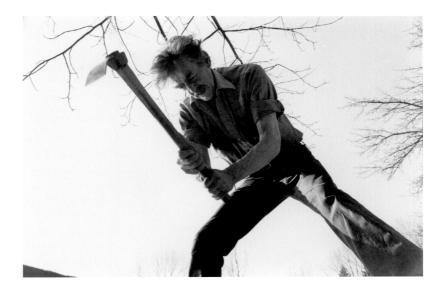

FIG. 28 Don Heiny: *Homer Page, Splitting Rails, Cornwall, Connecticut,* July 1976

One of the most salient qualities of Page's life was that he moved constantly forward. From California, to New York, to his years of globe-trotting, to the quiet woods of Connecticut, Page never looked back. While his life had disappointments, one imagines that there were few regrets. He lived by his wits and according to his own rules, propelled by a passionate curiosity and a deep sense of social and ethical responsibility.

The key motivating concept of Page's photographic career was the "documentary idea" he inherited from Dorothea Lange. This notion rested on a generous, encompassing vision of photographic practice—one with the capacity to forge a new union of world and self, logic and intuition, observation and understanding. The "documentary idea" was founded on a spirit of both celebration and critique, and dedicated to the dignity of human life. It also had deeply personal meaning. It signified a direct and honest engagement with reality—one with the potential to clarify and elevate both the subjects observed and the observing subject.

When Lange died in 1965, Page wrote a brief eulogy, "A Remembrance of Dorrie," for the professional journal *Infinity*.[74] In suggesting "a clue to Dorothea's greatness," Page observed that "she understood that vision comes before the camera. She also understood that true vision can only arise from a way of life." Page wrote from his heart and from his own experience. For him, the "documentary idea" had been enlarged and transformed over the decades, from an attitude toward photographing to a way of living. Page never turned his back on photography; he simply went where it pointed him.

ENDNOTES

1 "What Is Modern Photography?" *American Photography* 45 (March 1951): 147. The audio record of this remarkable gathering is available online at http://blogs.wnyc.org/culture/2008/05/27/streetshots-the-prequel/. My thanks to Don Heiny for this reference.

2 Author's transcription of WNYC audio record.

3 Author's transcription of WNYC audio record.

4 William Page was born in 1911, and John Morgan ("Jack") Page was born in 1916.

5 "Homer Page," in Carlton Brown, *Famous Photographers Tell How* (Greenwich, Conn.: Fawcett Publications, 1955), p. 76; "Homer Page," *U.S. Camera 1950* (New York: U.S. Camera, 1949), p. 193.

6 "Homer Page," Brown, *Famous Photographers Tell How*; and Page's Guggenheim application statement, November 1, 1948, courtesy John Simon Guggenheim Memorial Foundation.

7 The following chronology is based on existing published sources and the timeline established in Christina Gardner, *Homer Page: Portrait of a Photographer* (unpublished manuscript, 2001). Notably, in his Guggenheim application, Page stated that he attended the School of Design in 1939–40, worked at the Kaiser shipyards from March 1940 to June 1943, and was employed by Moulin Studios from June 1943 to September 1945.

8 Gardner, *Homer Page*, p. 11.

9 The following is indebted to Lloyd Engelbrecht, "Educating the Eye: Photography and the Founding Generation at the Institute of Design, 1937–46," in David Travis and Elizabeth Siegel, eds., *Taken by Design: Photographs from the Institute of Design, 1937–1971* (Chicago: Art Institute of Chicago/University of Chicago Press, 2002), pp. 16–33.

10 The following is indebted to Milton Meltzer, *Dorothea Lange: A Life* (New York: Farrar, Straus, and Giroux, 1978), pp. 238–42.

11 Quoted in Meltzer, *Dorothea Lange*, pp. 233–34.

12 Although the exact cause remained uncertain, Meltzer notes that Lange "suffered from intermittent epigastric distress, often accompanied by nausea and vomiting." Meltzer, *Dorothea Lange*, p. 249.

13 Gardner, *Homer Page*, p. 43.

14 Gardner, *Homer Page*, p. 43.

15 Meltzer, *Dorothea Lange*, pp. 247–49.

16 See Charles Wollenberg, *Photographing the Second Gold Rush: Dorothea Lange and the East Bay at War, 1941–1945* (Berkeley, Calif.: Heyday Books, 1995).

17 Gardner, *Homer Page*, p. 44.

18 Christiana Page, "The Reluctant Reformer," *Minicam* 9 (February 1946): 50–57, 144.

19 For an article on this exhibition, with a reproduction of one of Page's works, see Beaumont Newhall, "Dual Focus," *Art News* 45:4 (June 1946): 36–39, 54.

20 Gardner, *Homer Page*, p. 47.

21 Gardner, *Homer Page*, p. 53.

22 Gardner, *Homer Page*, p. 48.

23 Gardner, *Homer Page*, p. 56.

24 See, for example, Patricia Vettel-Becker, *Shooting from the Hip: Photography, Masculinity, and Postwar America* (Minneapolis: University of Minnesota Press, 2005), particularly chapter 3, "Tough Guys in the City: Cameramen and Street Photographers," pp. 61–85.

25 The timing of this career change remains slightly uncertain, with the dates given variously as 1943, 1944, and 1945. Christina Gardner recalls it as happening in 1945. In different sections of his Guggenheim application of November 1, 1948, Page gives the two earlier dates.

26 As Christina Gardner has noted, "If they sent you out on a small job such as to photograph a storefront, they issued you one film holder which held 2 pieces of film. If you used the second piece of film for the job, they asked you what went wrong." Gardner, *Homer Page*, p. 62.

27 Page's Guggenheim application, November 1, 1948.

28 The following is indebted to the definitive study of this subject, Stephanie Comer and Deborah Klochko's *The Moment of Seeing: Minor White at the California School of Fine Arts* (San Francisco: Chronicle Books, 2006).

29 Comer and Klochko, *The Moment of Seeing*, p. 12.

30 The timing of this program is significant. Academic courses in photography were just beginning a major conceptual reorientation: a shift from the context of trade and technical schools into departments of fine art. This transition was spurred by the interest in photography demonstrated by a swelling tide of GI Bill students returning from service in the war. For a study of an important contemporaneous program, see my essay "'To Open an Individual Way': Photography at the Institute of Design, 1946–61," in David Travis and Elizabeth Siegel, eds., *Taken by Design: Photographs from the Institute of Design, 1937–1971* (Chicago: Art Institute of Chicago/University of Chicago Press, 2002), pp. 69–91.

31 Comer and Klochko, *The Moment of Seeing*, p. 39. The painting faculty at this time included Elmer Bischoff, Clyfford Still, and Hassel Smith.

32 Page's classroom notes; courtesy Jeanne Russo Page and Don Heiny.

33 Comer and Klochko, *The Moment of Seeing*, p. 38.

34 Page's lecture notes; courtesy Jeanne Russo Page and Don Heiny.

35 Page's lecture notes; courtesy Jeanne Russo Page and Don Heiny.

36 Gardner, *Homer Page*, pp. 78–79.

37 Page's assignments included one from *Ladies Home Journal* to photograph a home for unwed mothers in Pennsylvania; a "small effort" for Roy Stryker, at Standard Oil; and a

project to make portraits of architects for the Museum of Modern Art. Gardner, *Homer Page*, p. 90.

38 Gardner, *Homer Page*, pp. 86–87.

39 Gardner, *Homer Page*, pp. 87–88.

40 Page's Guggenheim application file; courtesy, John Simon Guggenheim Memorial Foundation.

41 Page to Lange, May 2, 1949; all quotes from Page's letters to Dorothea Lange, courtesy Christina Gardner.

42 Page to Lange, May 26, 1949.

43 Page to Lange, May 2, 1949.

44 In this regard, it is interesting to note that, in a letter of May 19, 1949, Lange urged Page to study the publication *Balinese Character: A Photographic Analysis*, by Gregory Bateson and Margaret Mead (Special Publications of the New York Academy of Sciences, vol. 2 [New York: New York Academy of Sciences, 1942]). In this remarkable volume, 759 photographs are employed to illustrate 100 themes or subjects, grouped under headings such as "Spatial Orientation and Levels," "Learning," "Orifices of the Body," "Parents and Children," "Siblings," "Stages of Child Development," and "Rites de Passage."

45 Page to Lange, May 2, 1949.

46 Page to Lange, May 26, 1949.

47 Page to Lange, October 3, 1949.

48 Page to Lange, undated.

49 W. H. Auden, *The Age of Anxiety: A Baroque Eclogue* (New York: Random House, 1947).

50 The many fine studies of this period include Paul Boyer, *By the Bomb's Early Light: American Thought and Culture at the Dawn of the Atomic Age* (Chapel Hill: University of North Carolina Press, 1994); and John Lewis Gaddis, *The Cold War: A New History* (New York: Penguin Books, 2005).

51 "Red Case Contempt Jails 3 of Accused at Stormy Session," *New York Times*, June 4, 1949, 1; "Wallace Protests Jailing of 3 Reds," *New York Times*, June 5, 1949, 2. The newspapers on the ground in this photograph are copies of the *Daily Worker*.

52 While the literature on these subjects is nearly endless, the following studies are highly recommended: Daniel Belgrad, *The Culture of Spontaneity: Improvisation and the Arts in Postwar America* (Chicago: University of Chicago Press, 1998); Michael Leja, *Reframing Abstract Expressionism: Subjectivity and Painting in the 1940s* (New Haven: Yale University Press, 1993); Scott DeVeaux, *The Birth of Be-Bop: A Social and Musical History* (Berkeley: University of California Press, 1997); James Naremore, *More Than Night: Film Noir in Its Contexts* (Berkeley: University of California Press, 1998); J. P. Telotte, *Voices in the Dark: The Narrative Patterns of Film Noir* (Urbana: University of Illinois Press, 1989); Nicholas Christopher, *Somewhere in the Night: Film Noir and the American City* (New York: Free Press, 1997); and Joan Copjedc, ed., *Shades of Noir: A Reader* (London: Verso, 1993).

53 For example, see Bernard Rosenberg and David Manning White, eds., *Mass Culture: The Popular Arts in America* (New York: Free Press, 1957).

54 See, for example, Marjorie Grene, *Dreadful Freedom: A Critique of Existentialism* (Chicago: University of Chicago Press, 1948); and George Cotkin, *Existential America* (Baltimore: Johns Hopkins University Press, 2003).

55 General histories of this period include David Halberstam, *The Fifties* (New York: Fawcett Columbine, 1993); and James T. Patterson, *Grand Expectations: The United States, 1945–1974* (New York: Oxford University Press, 1996). Other studies, focusing more closely on the cultural vitality of this period, include Morris Dickstein, *Leopards in the Temple: The Transformation of American Fiction, 1945–1970* (Cambridge, Mass.: Harvard University Press, 2002); and Andrew Jamison and Ron Eyerman, *Seeds of the Sixties* (Berkeley: University of California Press, 1994).

56 In March 1950, Page made a large series of images in the offices of the McGraw-Hill publishing firm. Many of these were of female employees [PL. 16]. Filed with these negatives is a note in his handwriting: "The curve of working wives is rising rapidly. Why? What changes at work? In the home? In business?" Courtesy Jeanne Russo Page.

57 Charles Baudelaire, *The Painter of Modern Life and Other Essays*, trans. and ed. by Jonathan Mayne (New York: DaCapo Press, 1986), p. 9.

58 Charles Baudelaire, *Oeuvres complètes* (Paris: Editions Gallimard, 1961), pp. 243–44; cited in Burton Pike, *The Image of the Modern City* (Princeton: Princeton University Press, 1981), p. 25.

59 In 1940, President Franklin D. Roosevelt designated the third Sunday in May as "I Am an American Day." In 1952, President Harry S. Truman signed a bill to rename the holiday "Citizenship Day" and to move it to September 17.

60 Of course, this title also makes clear reference to the newspaper at the top of the display rack.

61 Cecil Hemley, "The Problem of the Paperbacks," *Commonweal* 61 (1954): 95–97; reprinted in Rosenberg and White, *Mass Culture*, pp. 141–44. On this subject, see also Woody Haut, *Pulp Culture: Hardboiled Fiction and the Cold War* (London: Serpent's Tail, 1995); and Lee Server, *Over My Dead Body: The Sensational Age of the American Paperback: 1945–1955* (San Francisco: Chronicle Books, 1994).

62 The key study of this subject remains Jane Livingston, *The New York School: Photographs 1936–1963* (New York: Stewart, Tabori, and Chang, 1992). See also Max Kozloff, *New York: Capital of Photography* (New York: Jewish Museum/Yale University Press, 2002). For a brief overview of this subject, see Keith F. Davis, *An American Century of Photography: From Dry-Plate to Digital, The Hallmark Photographic Collection, Second Edition, Revised and Enlarged* (Kansas City: Hallmark Cards/Harry N. Abrams, 1999), pp. 275–96.

63 Page to Lange, January 5, 1949.

64 Appendix D. For a published version of this talk, see "A Photo League Symposium," *Photo Notes* (Spring 1950): 17–18.

65 See, respectively, *The West: A Portfolio of Photographs* (Colorado Springs: Colorado Springs Fine Art Center, n.d. [1953]); and *Catalogue of the Exhibition of Contemporary Photography* (Tokyo: National Museum of Modern Art, 1953).

66 Magnum press release, June 23, 1950; courtesy Christina Gardner; email correspondence from Inge Bondi, May 2, 2008; and Russell Miller, *Magnum: Fifty Years at the Front Line of History* (New York: Grove Press, 1997), p. 70. Christina Gardner recalls that the cost of joining the group was $600.

67 Magnum press release, June 23, 1950. None of these three names is indexed in Miller, *Magnum*.

68 See, for example, Inge Bondi's recollection in Miller, *Magnum*, p. 72.

69 Inge Bondi, email correspondence, May 2, 2008.

70 Page and Marjorie separated in the early 1970s and were divorced in 1979. Page had also been married for a brief time in the 1950s—a relationship that ended in annulment.

71 My thanks to Jeanne Russo Page for this information.

72 "Homer Gordon Page, photographer, writer," *Waterbury Republican* (Sept. 10, 1985): A5. Courtesy Christina Gardner.

73 Jeanne Russo Page, conversation with the author, January 17, 2008.

74 Homer Page, "A Remembrance of Dorrie," *Infinity* 14 (November 1965): 26–27.

New York 1949–50

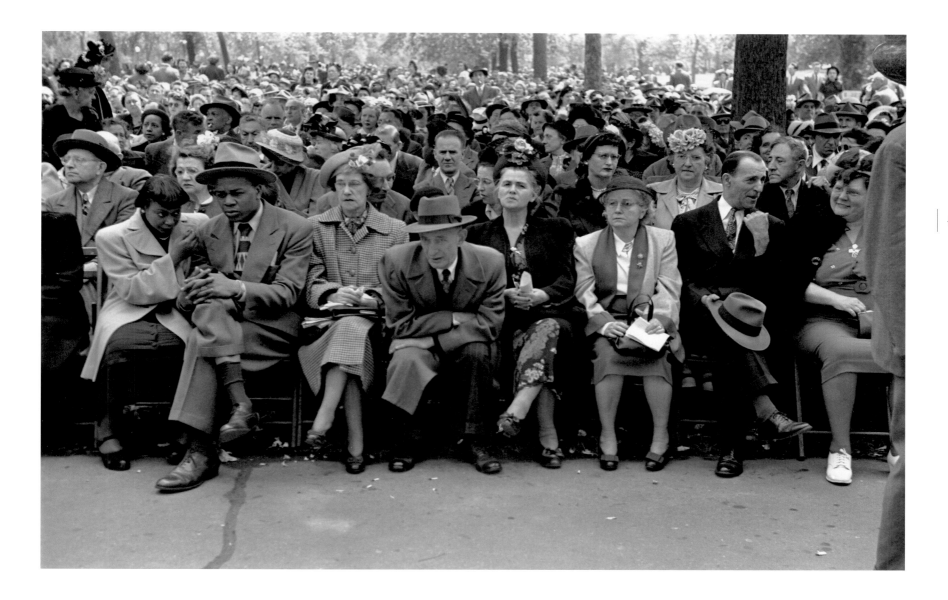

1 *New York ("I Am an American Day")*, May 15, 1949

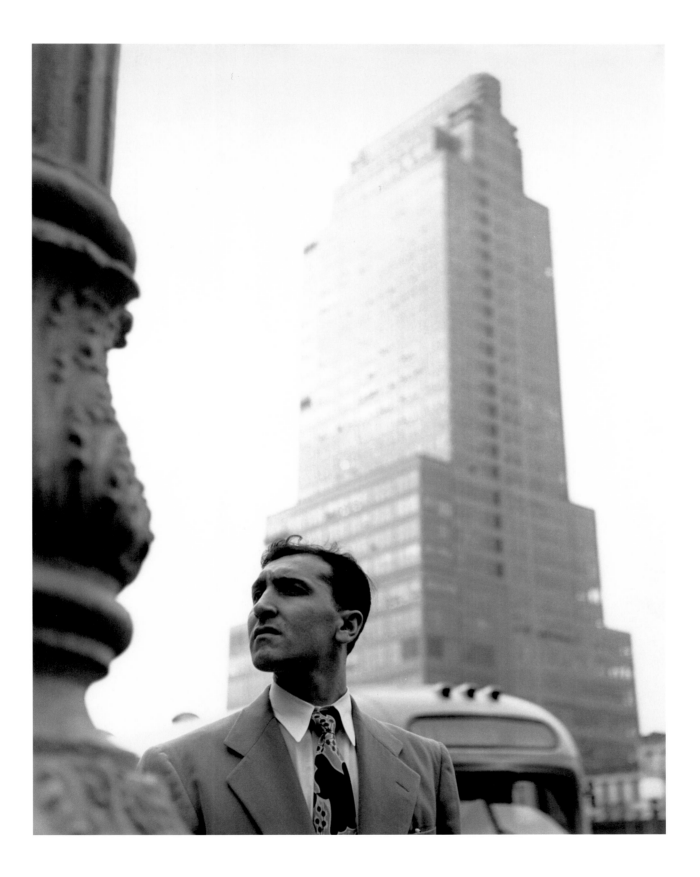

2 *New York*, June 28, 1949

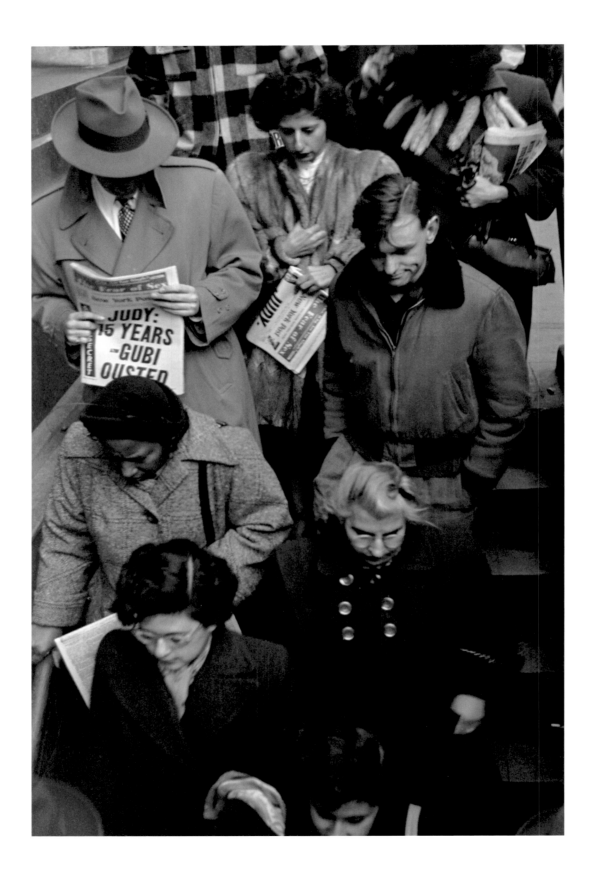

3 *New York*, ca. March 9, 1950

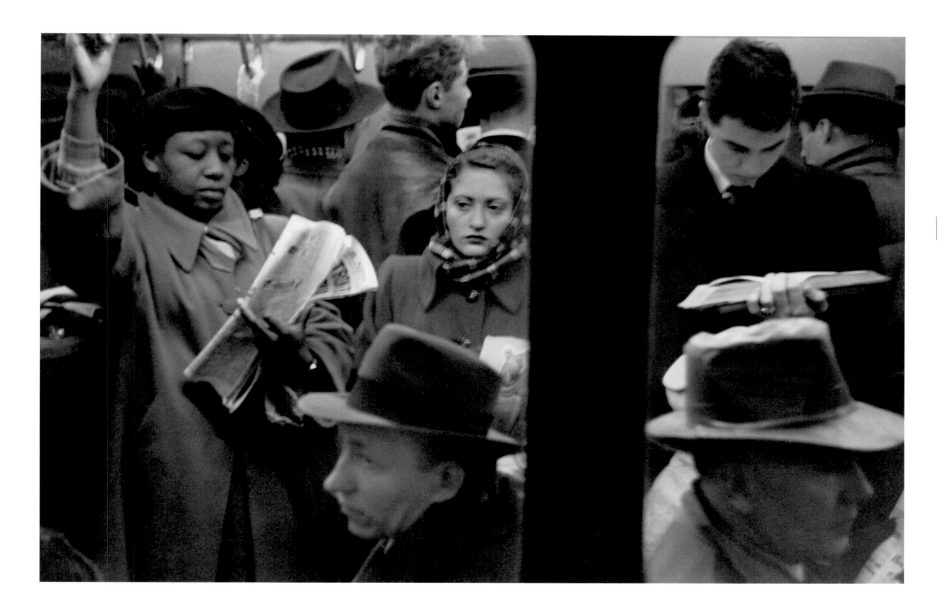

4 *New York*, February 14, 1950

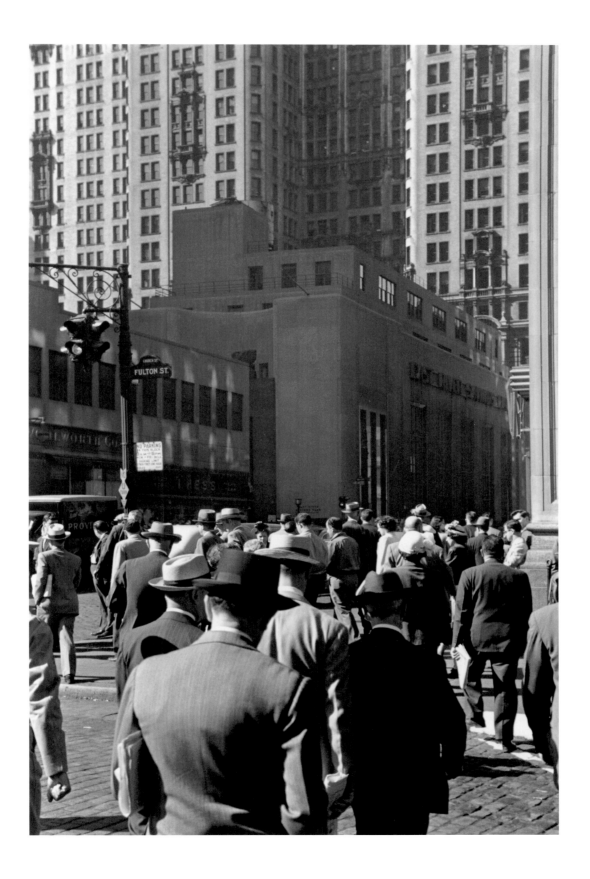

5 *New York ("Another Day")*, June 8, 1949

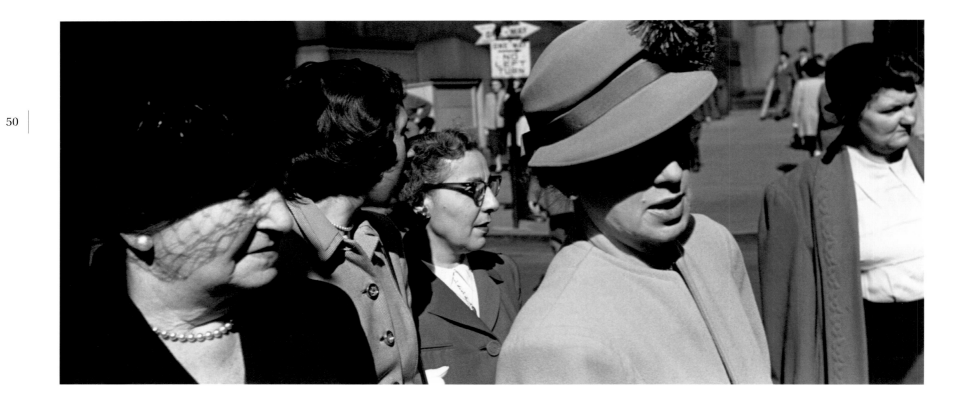

6 *New York*, October 21, 1949

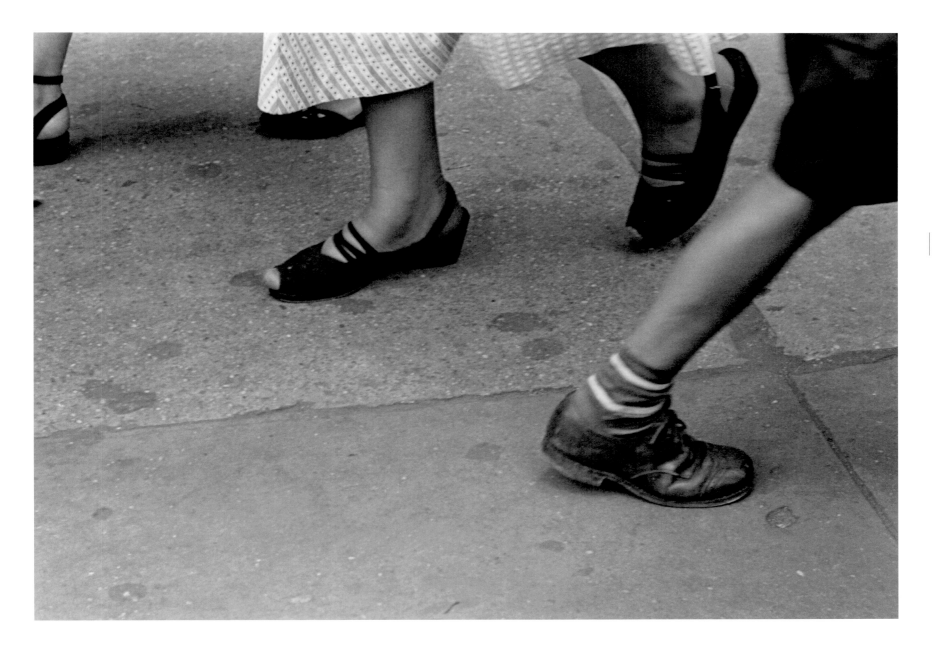

7 *New York*, July 28, 1949

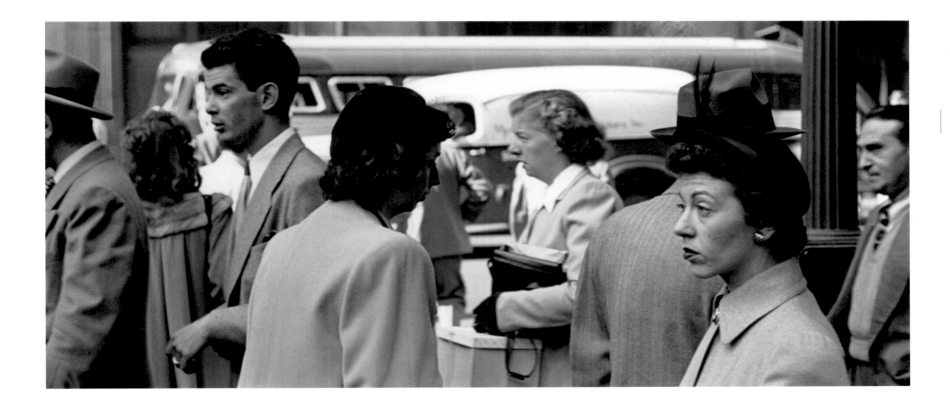

8 *New York*, October 24, 1949

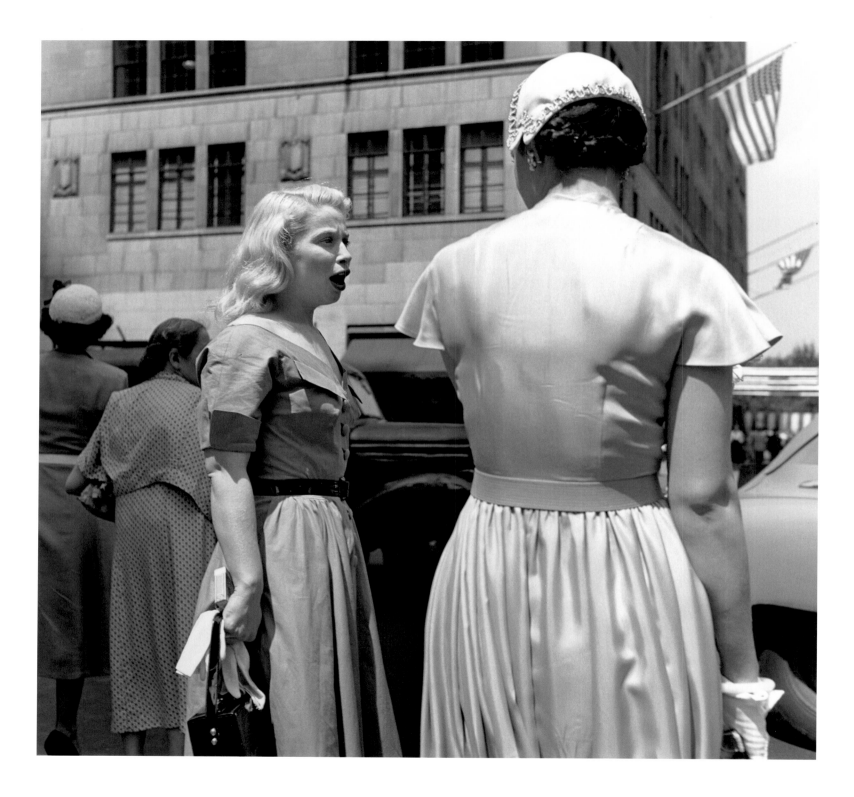

9 *New York*, July 14, 1949

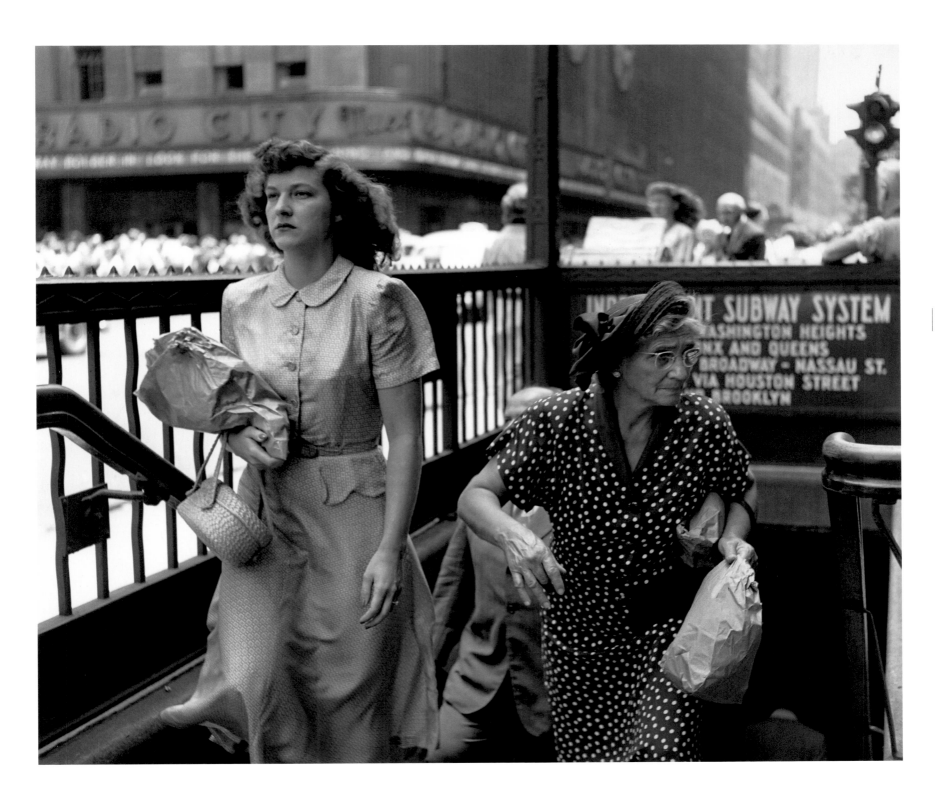

10 *New York*, July 14, 1949

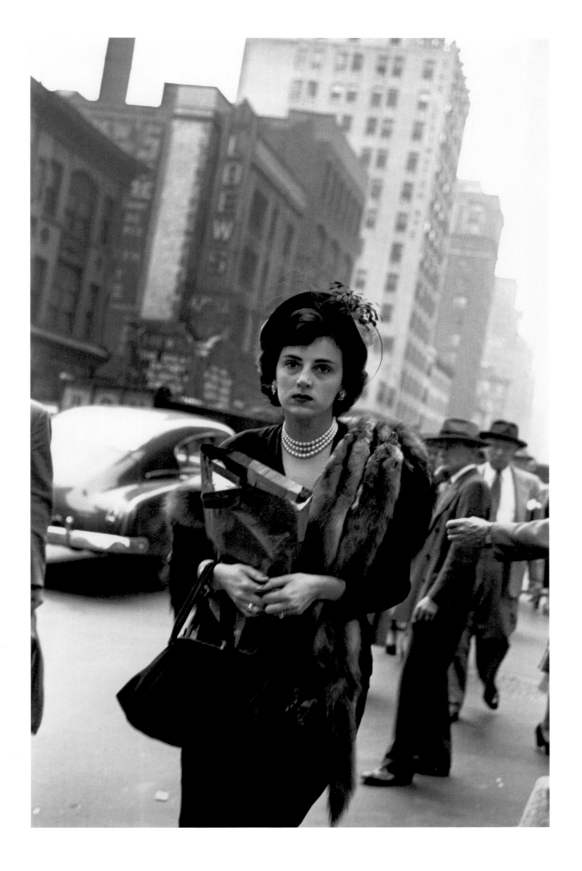

11 *New York*, September 16, 1949

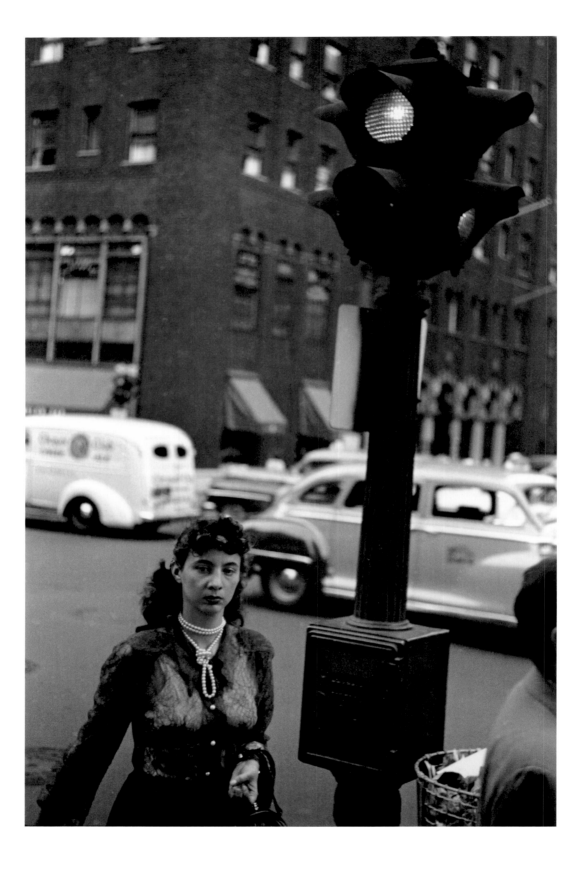

12 *New York*, October 11, 1949

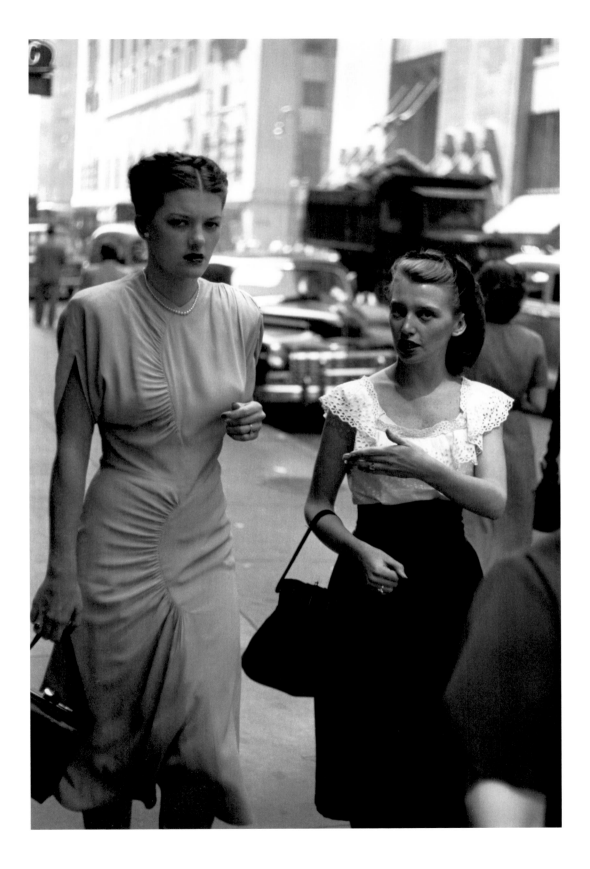

13 *New York*, September 1, 1949

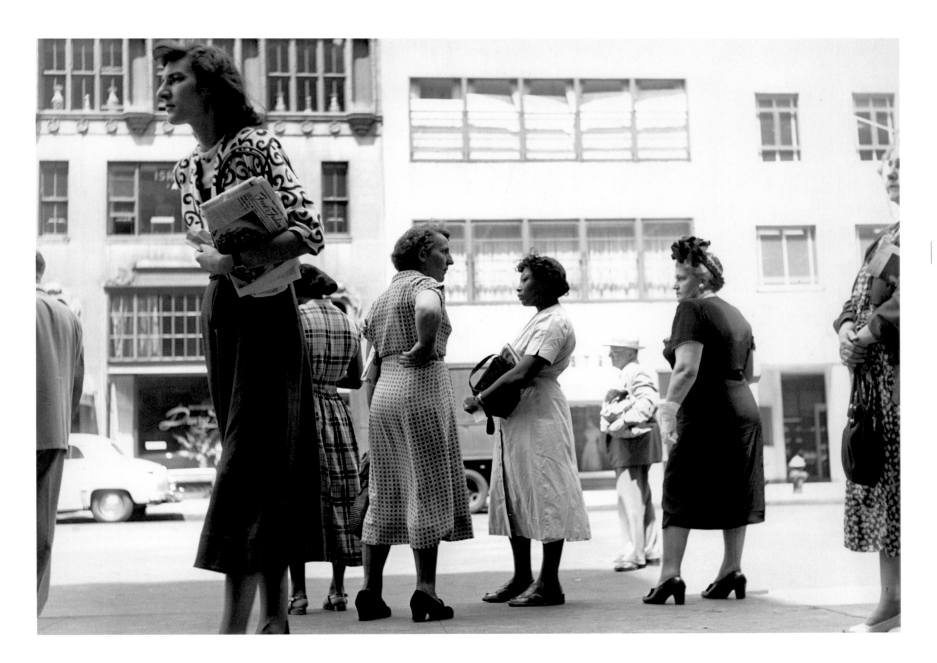

14 *New York*, July 14, 1949

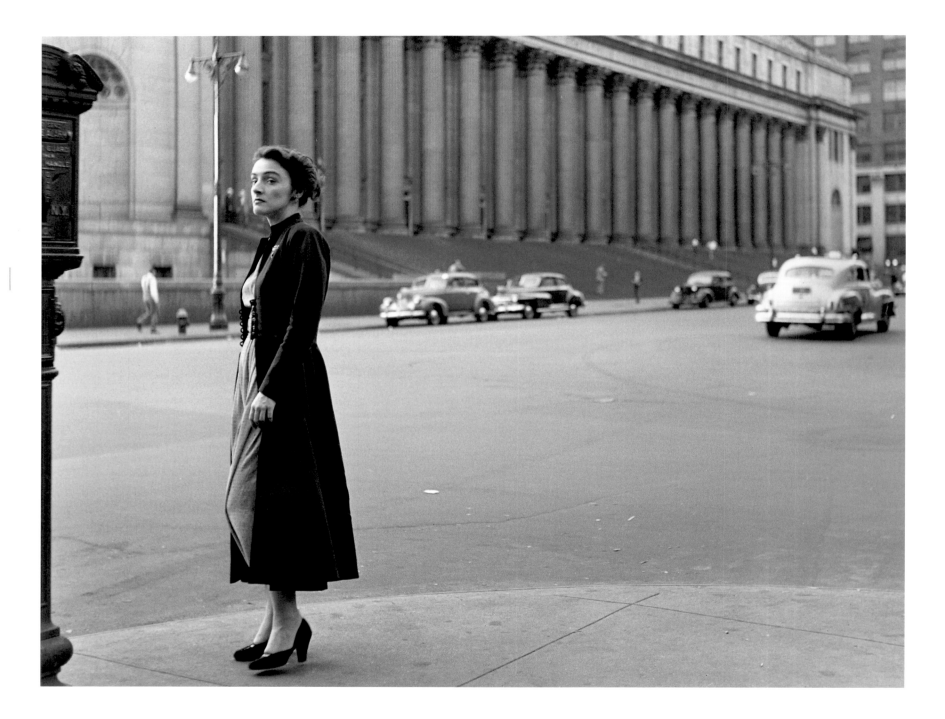

15 *New York*, June 19, 1949

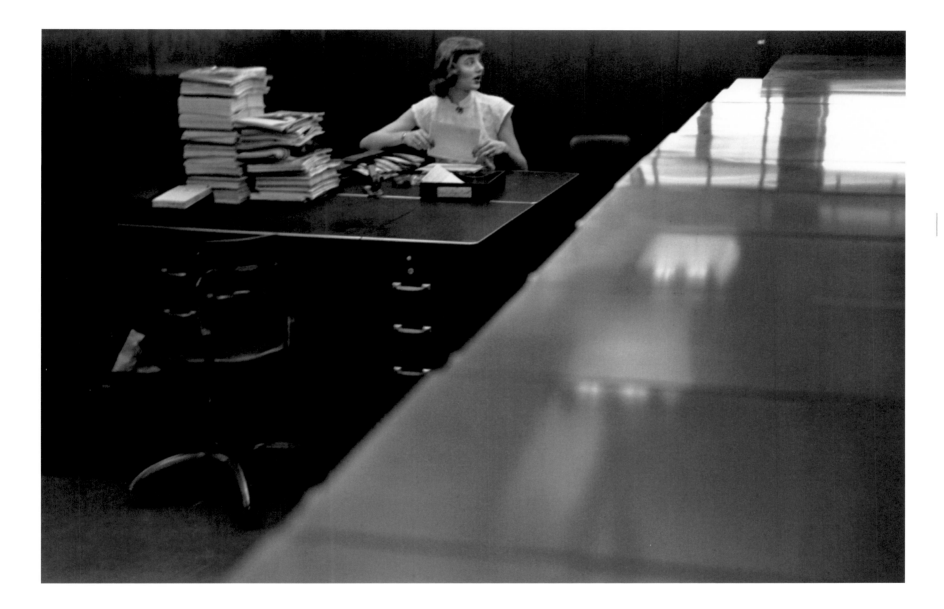

16 *New York*, ca. March 23, 1950

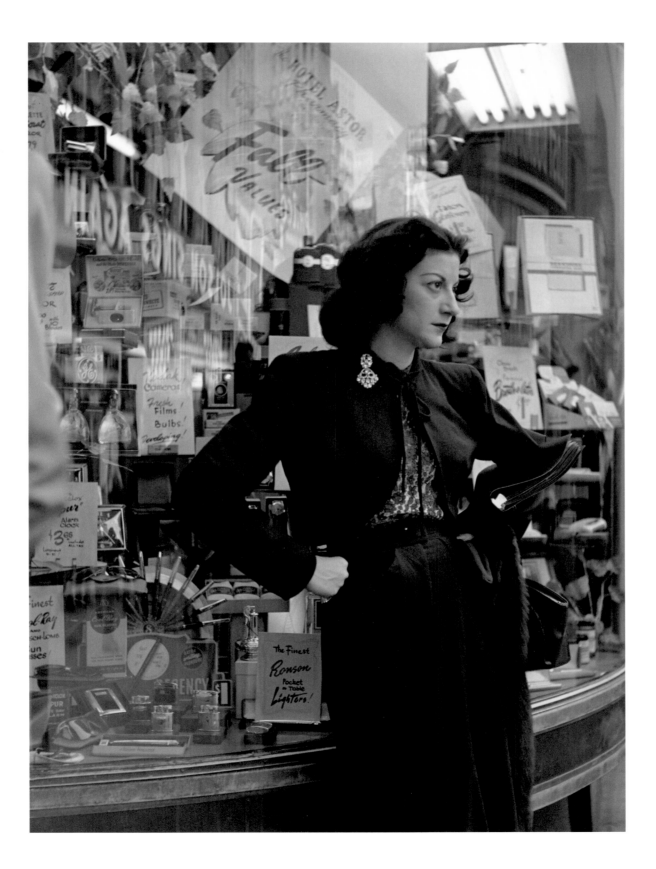

17 *New York*, September 16, 1949

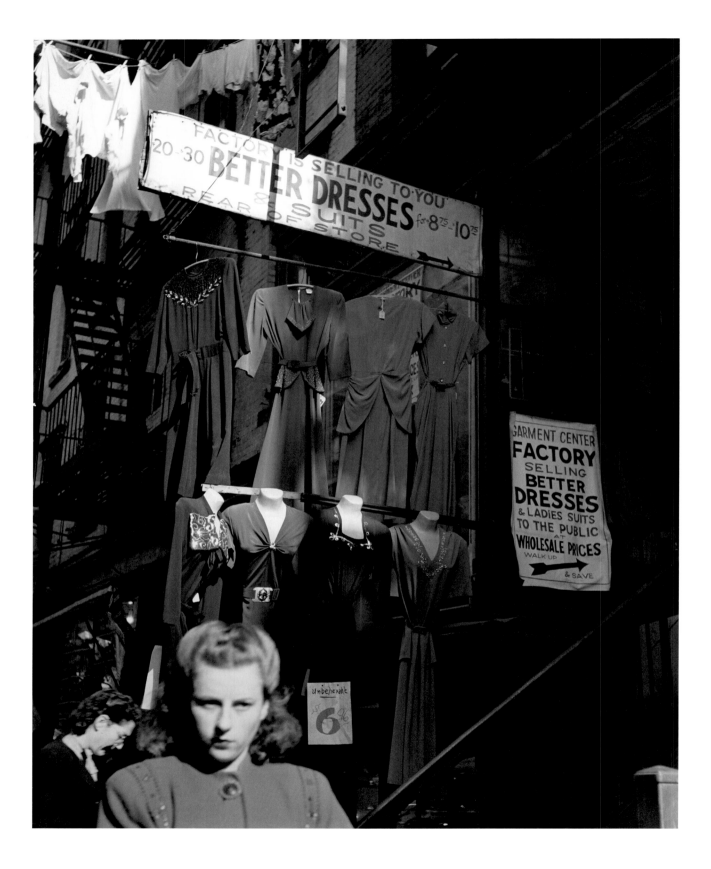

18 *New York,* ca. October, 1949

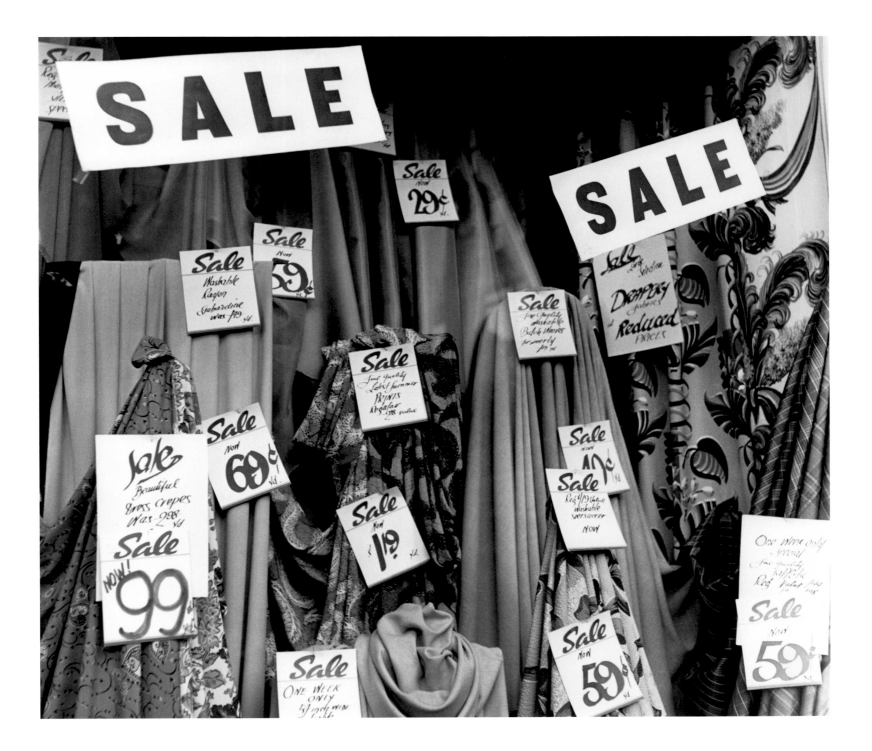

19 *New York*, June 19, 1949

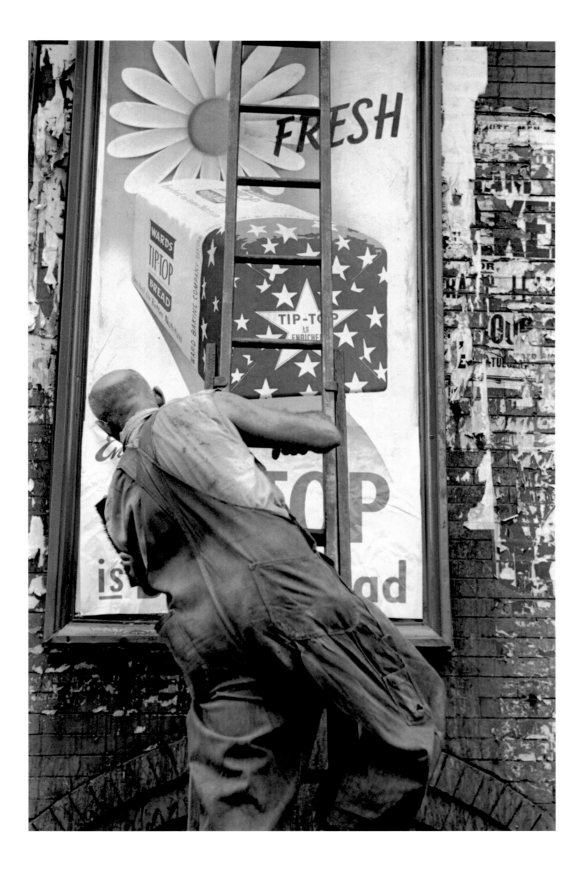

20 *New York*, August 11, 1949

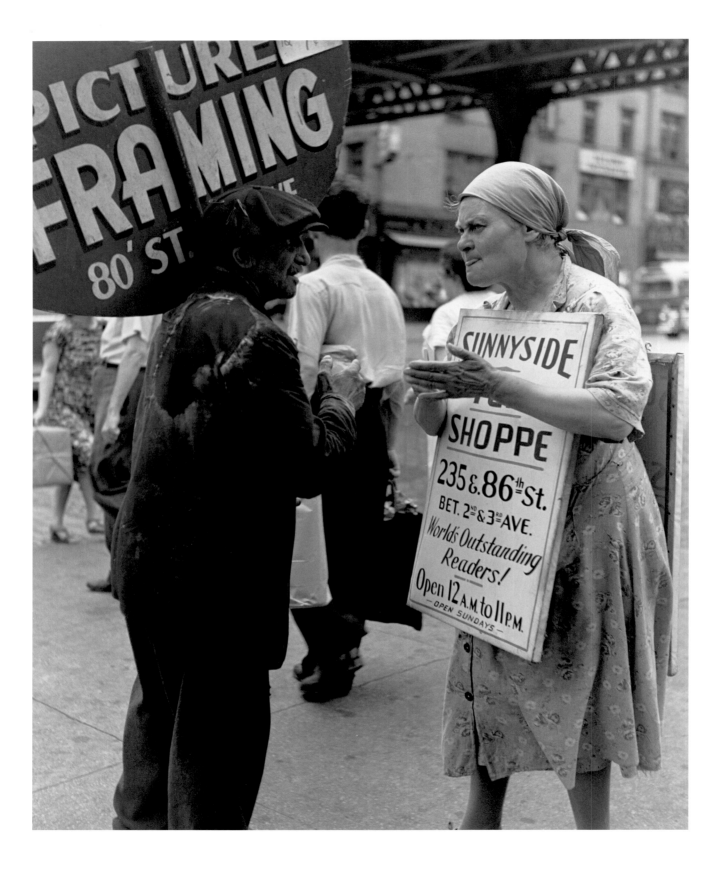

21 *New York*, July 22, 1949

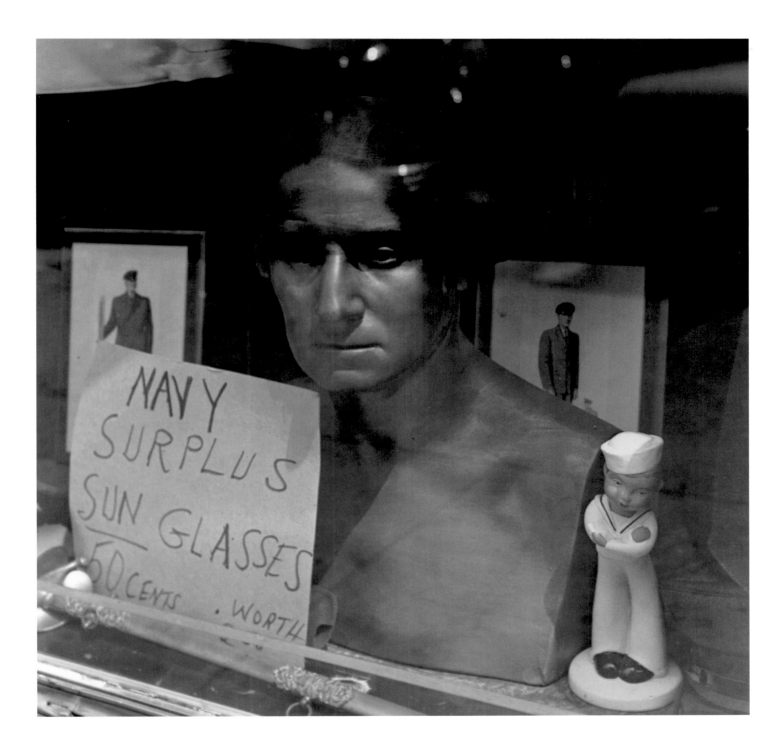

22 *New York*, July 1, 1949

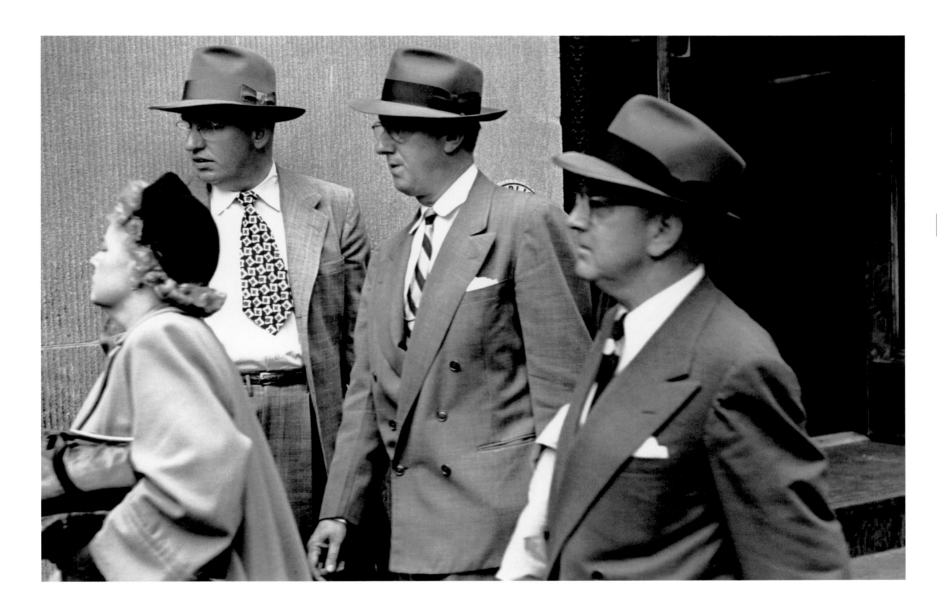

23 *New York*, September 16, 1949

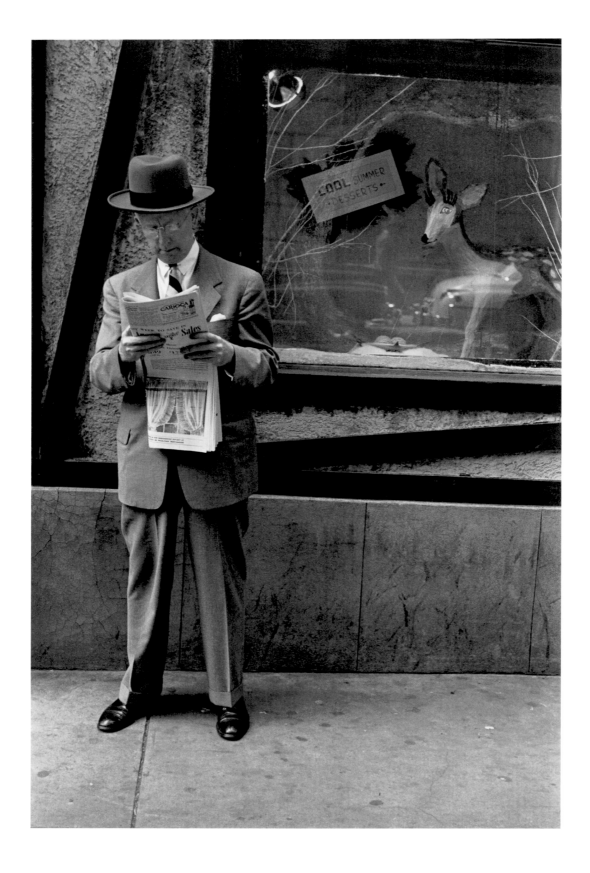

24 *New York*, August 22, 1949

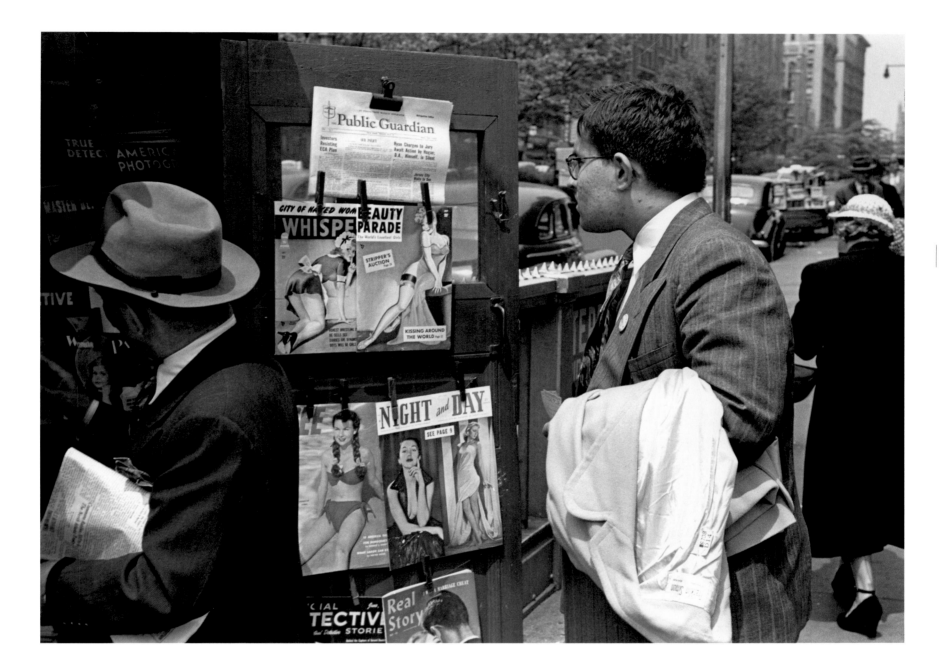

25 *New York ("Public Guardian")*, May 13, 1949

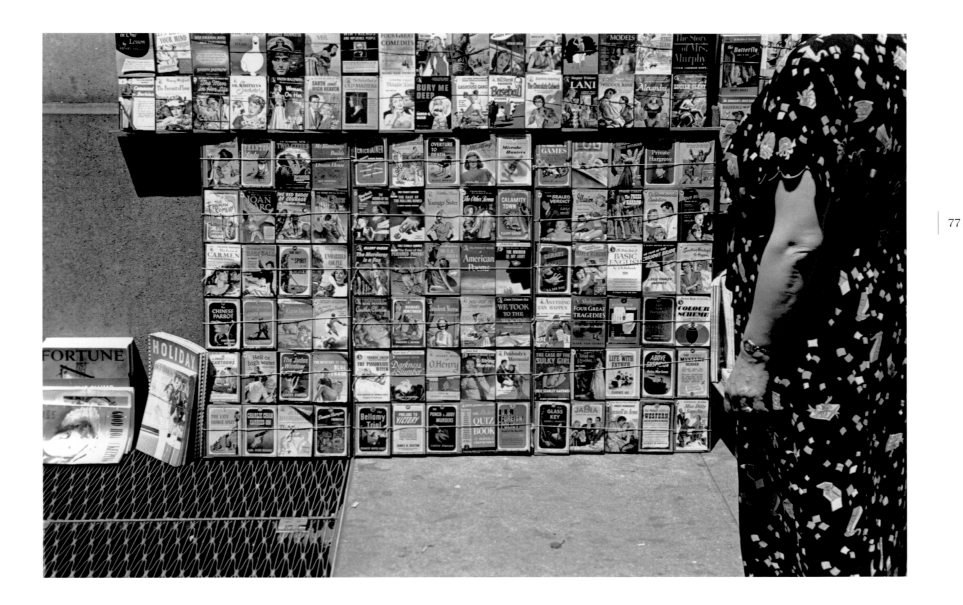

26 *New York*, June 6, 1949

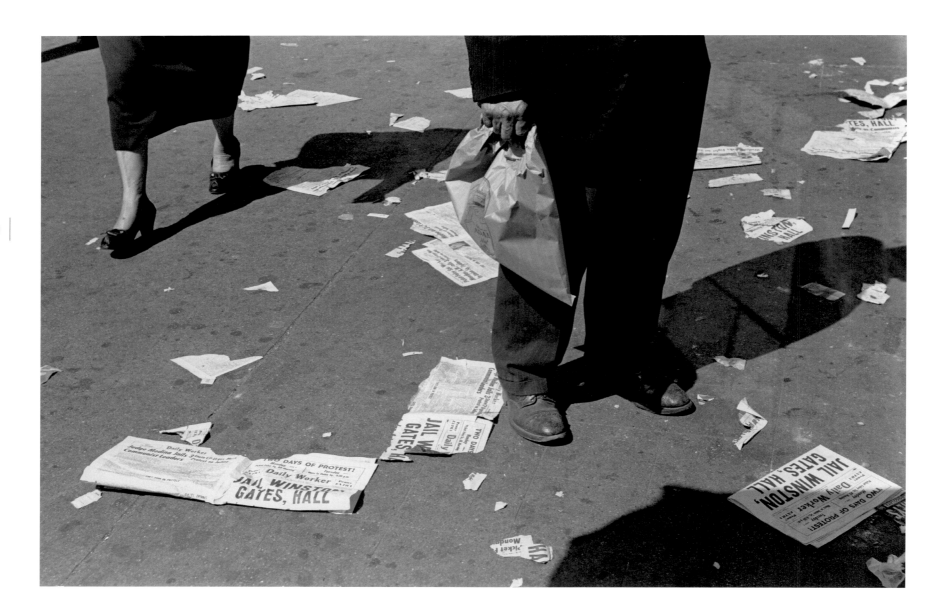

27 *New York ("Two Days of Protest")*, June 3, 1949

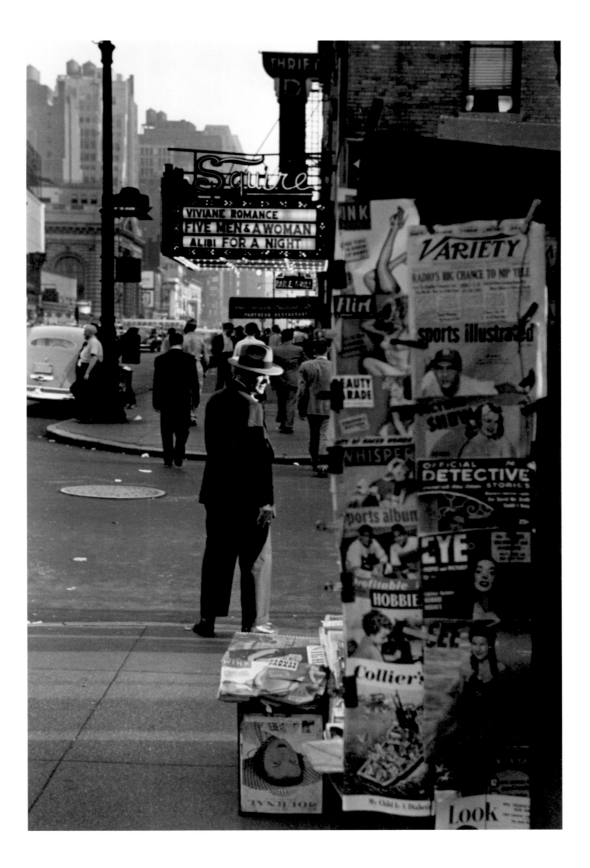

28 *New York*, June 11, 1949

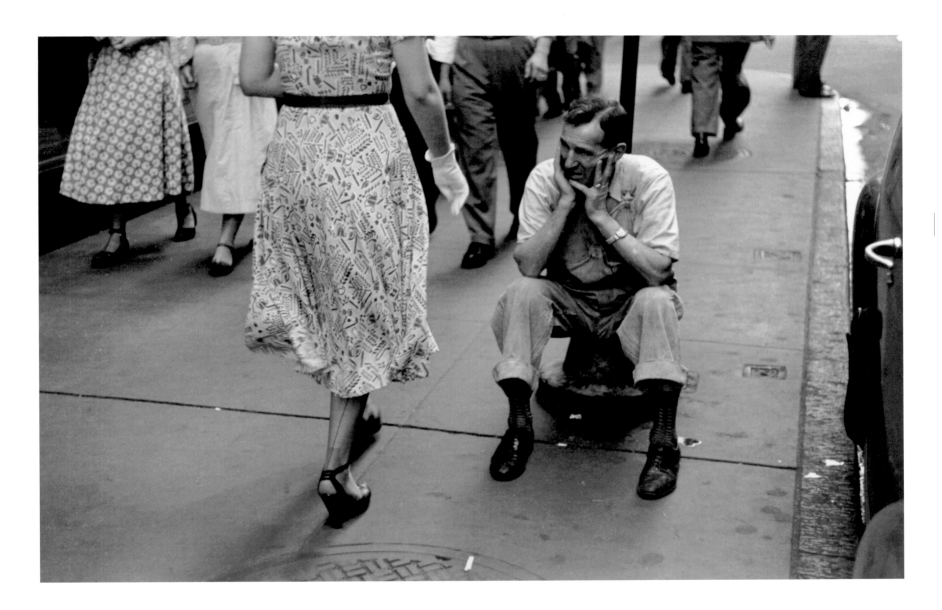

29 *New York*, September 1, 1949

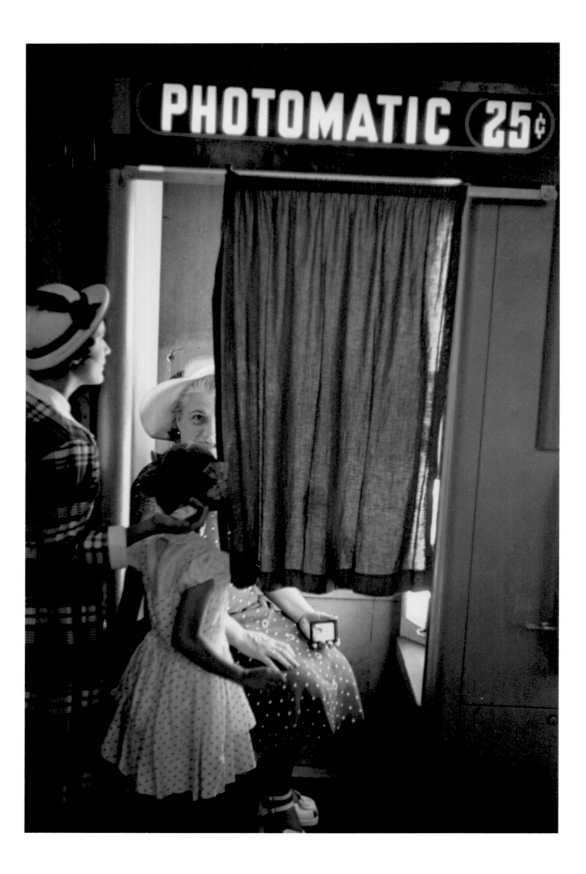

30 *New York*, August 20, 1949

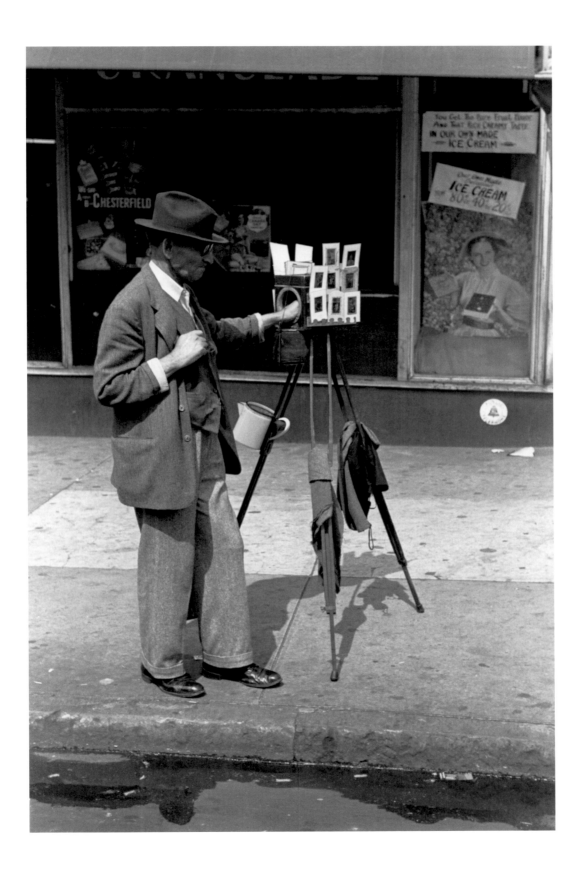

31 *New York*, August 30, 1949

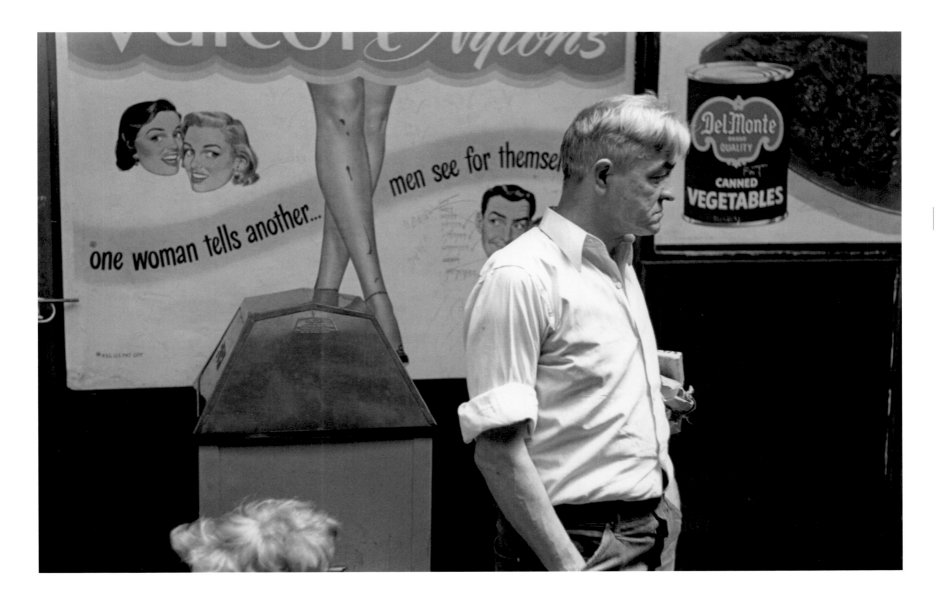

32 *New York*, May 11, 1949

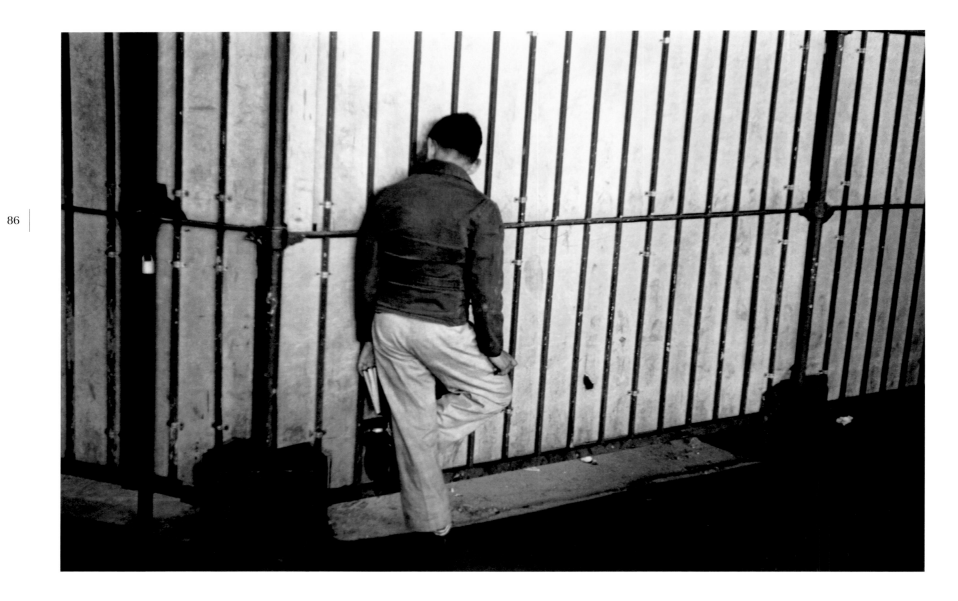

33 *New York*, September 10, 1949

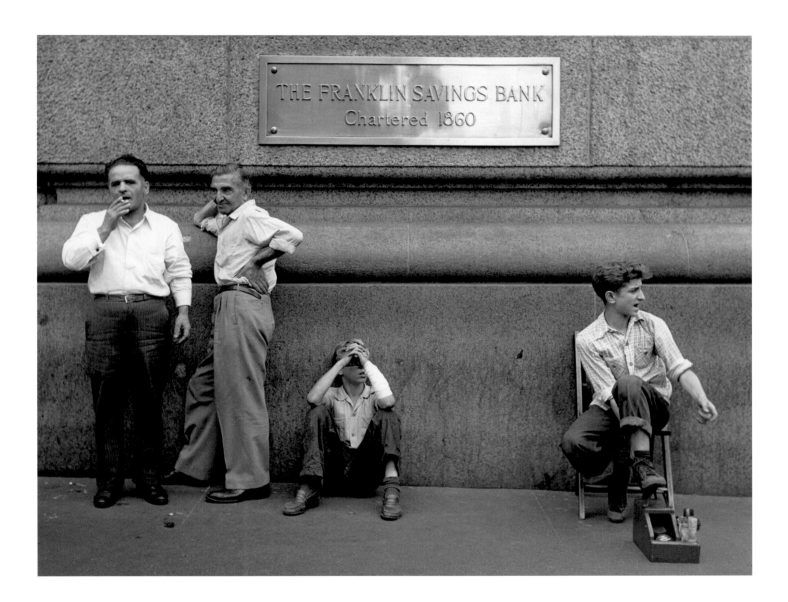

34 *New York,* June 28, 1949

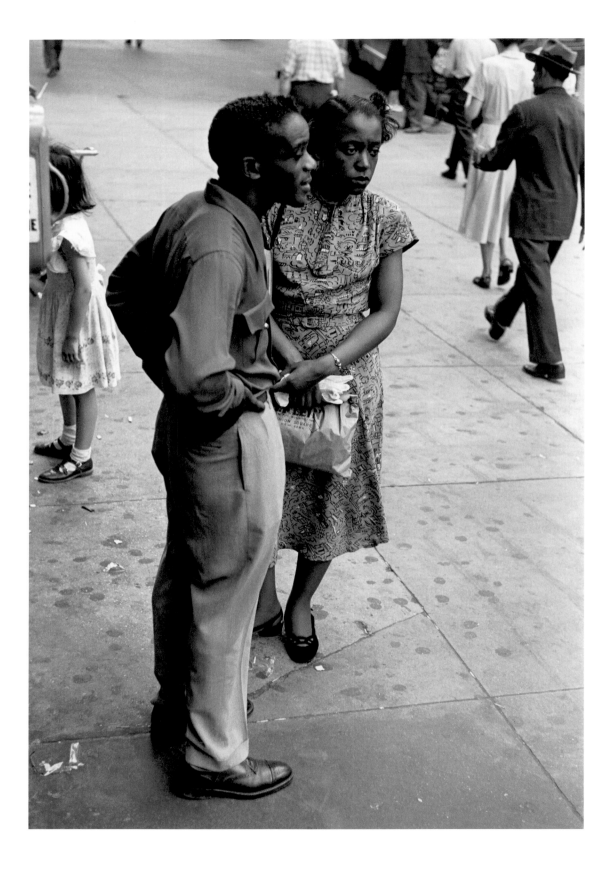

35 *New York*, June 16, 1949

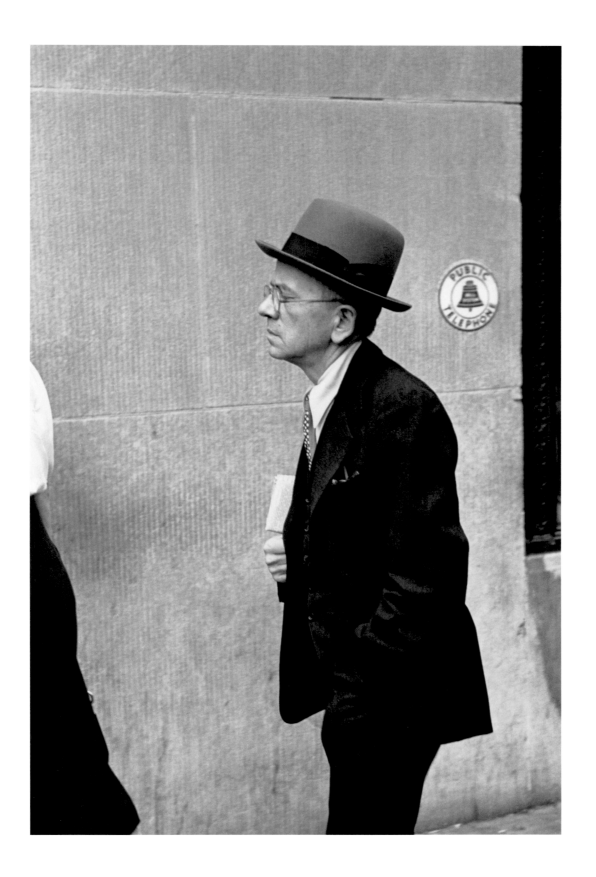

36 *New York*, September 16, 1949

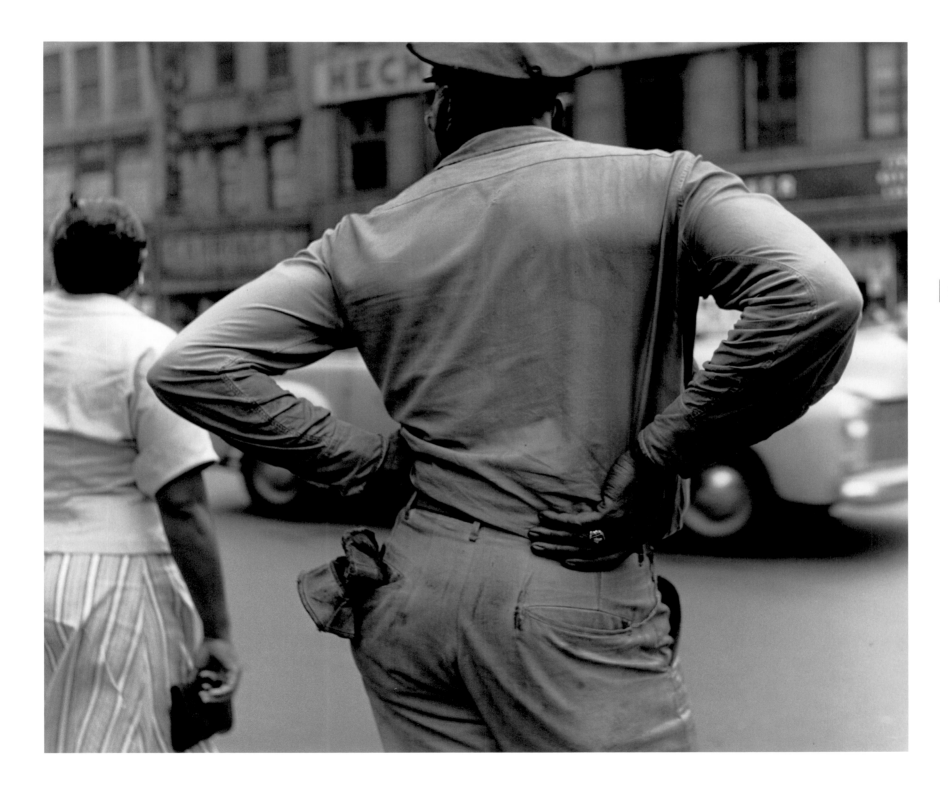

37 *New York*, June 27, 1949

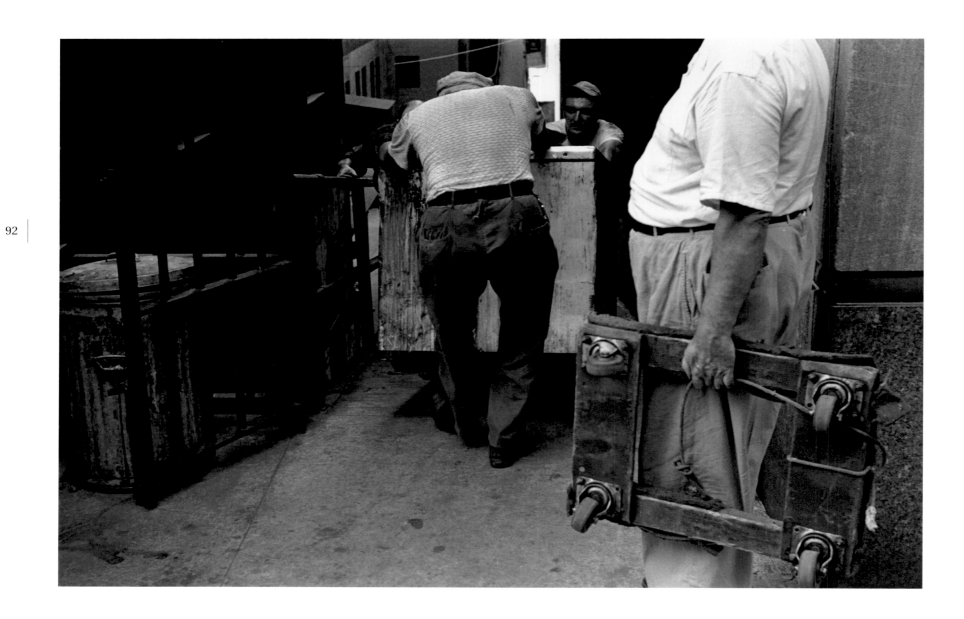

38 *New York*, August 11, 1949

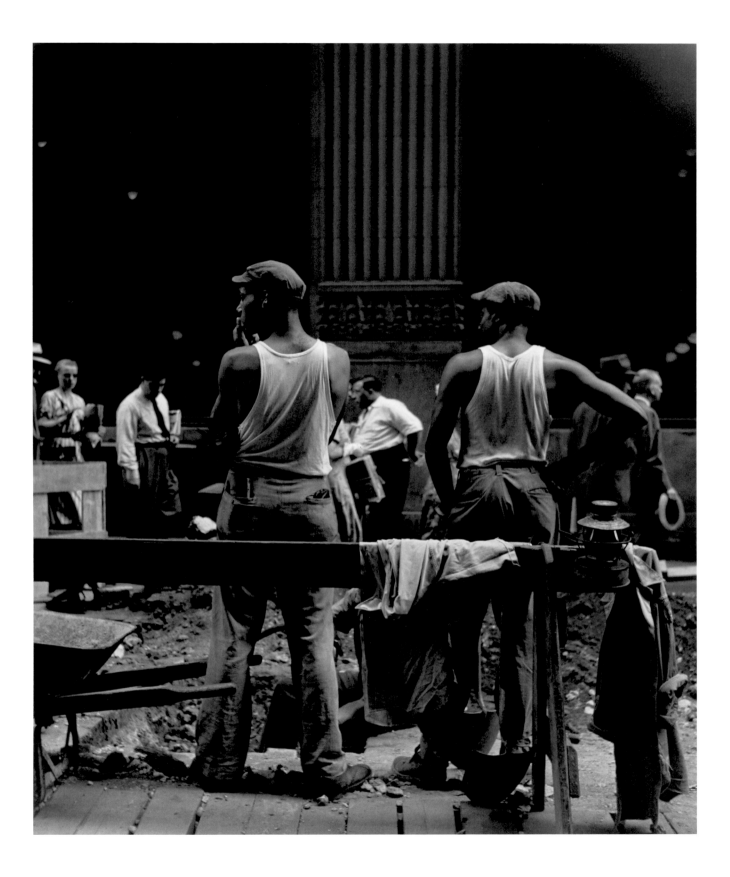

39 *New York*, June 22, 1949

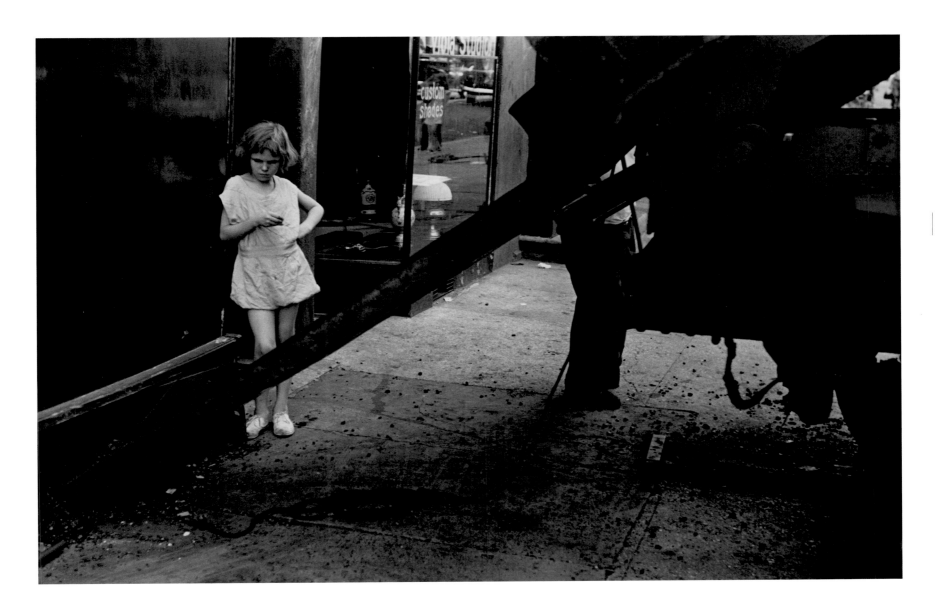

40 *New York*, August 11, 1949

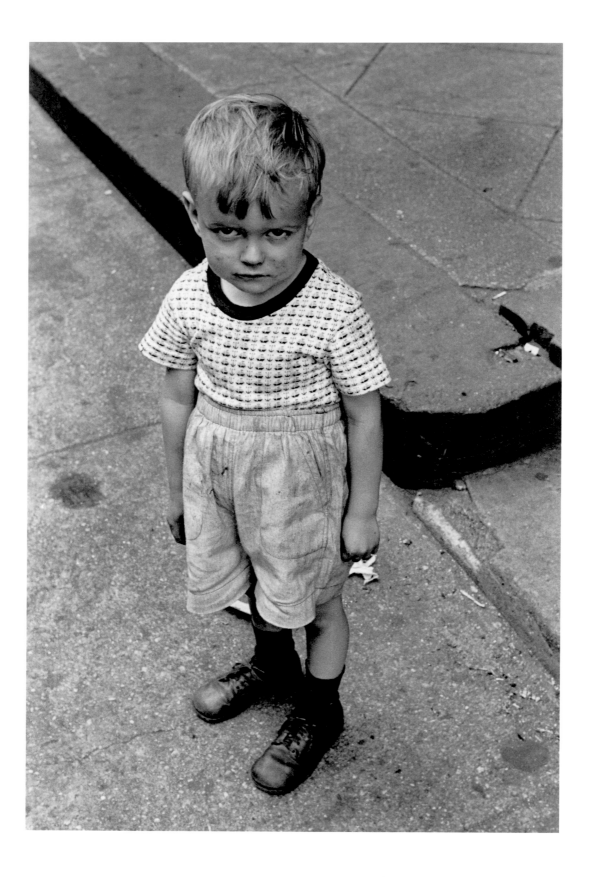

41 *New York*, June 16, 1949

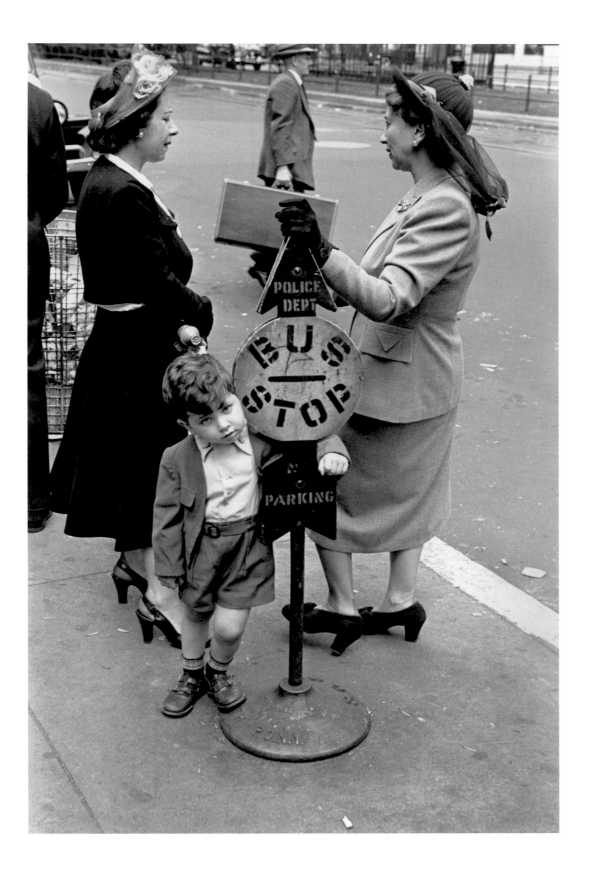

42 *New York*, May 31, 1949

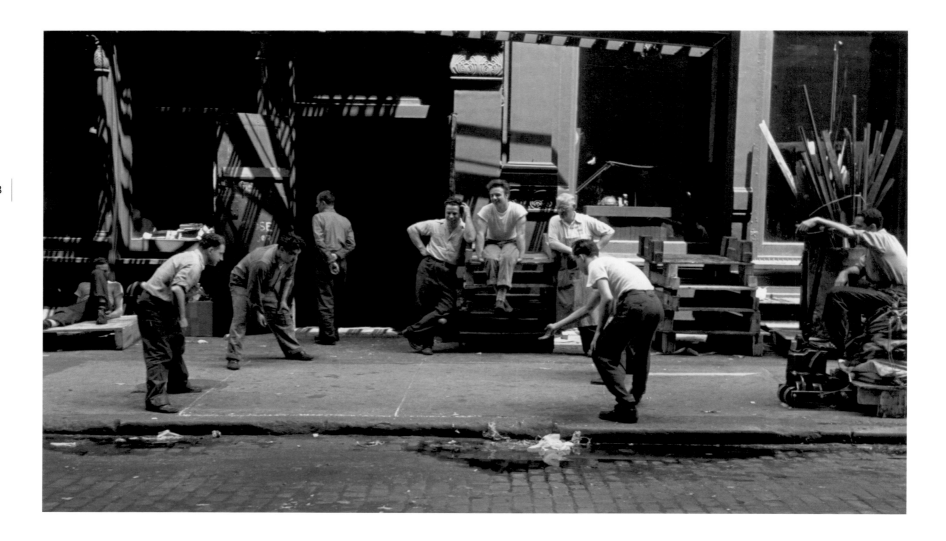

43 *New York*, May 5, 1949

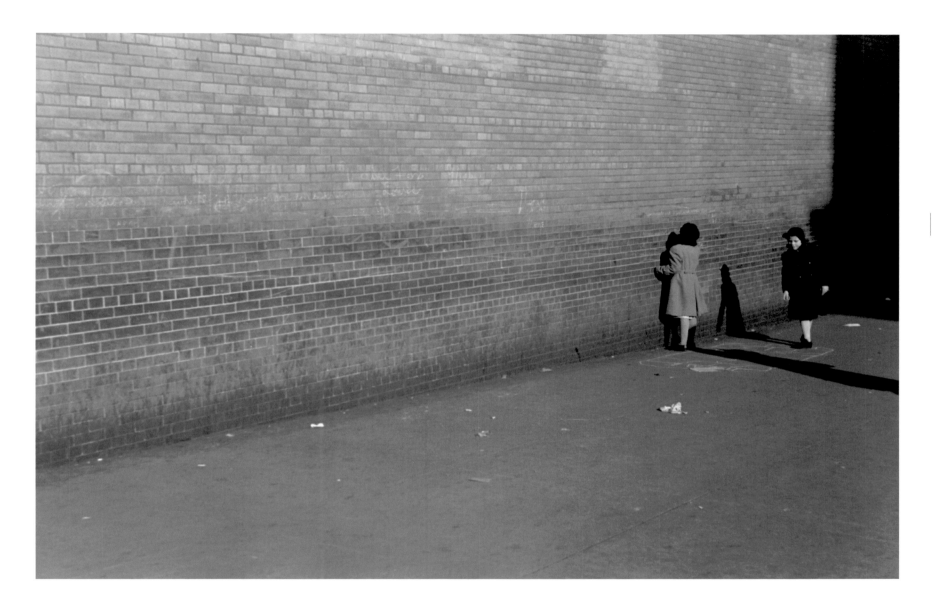

44 *New York,* March 4, 1950

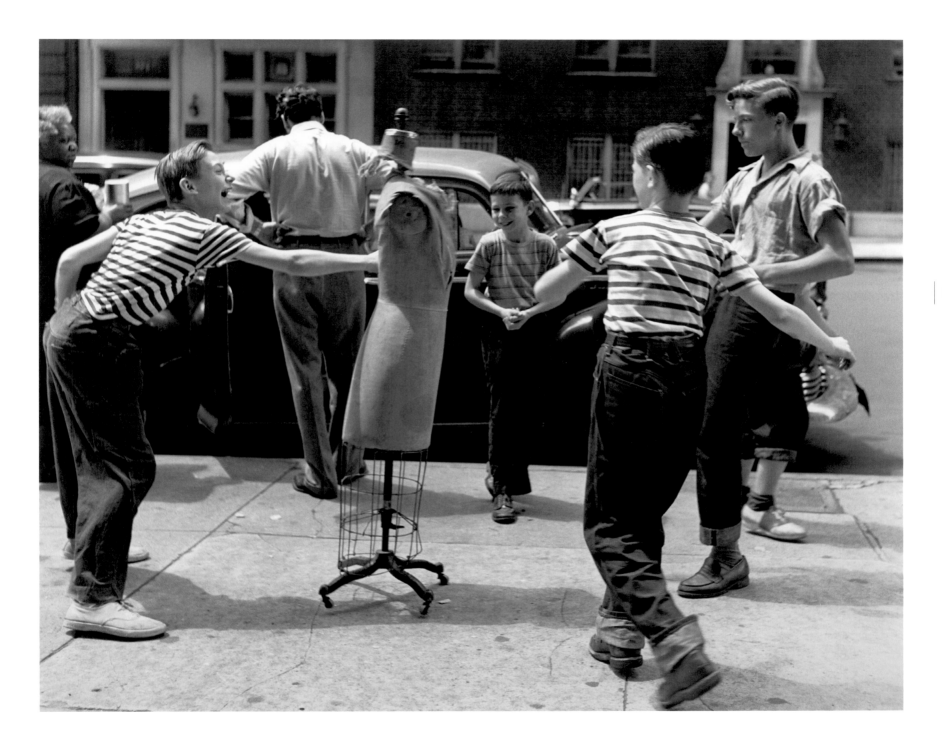

45 *New York*, June 18, 1949

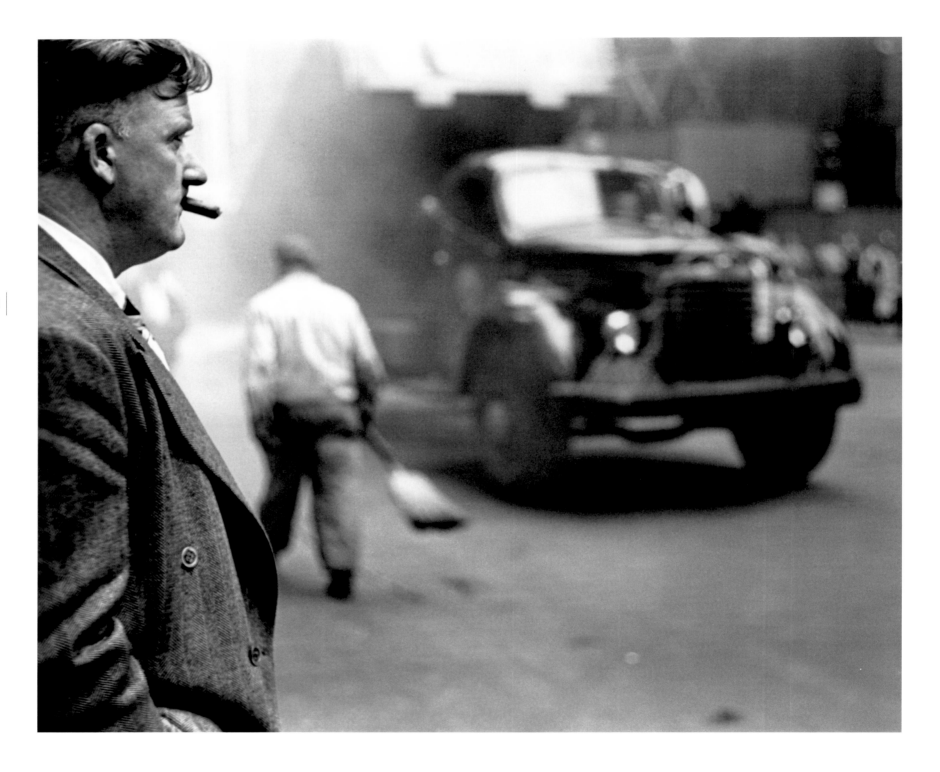

46 *New York*, September 16, 1949

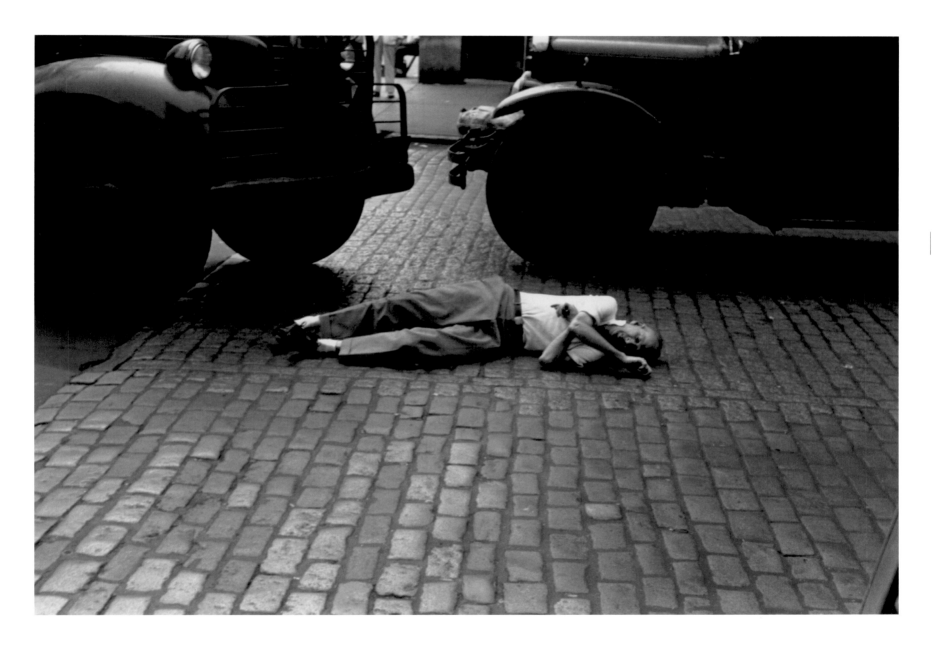

47 *New York*, August 30, 1949

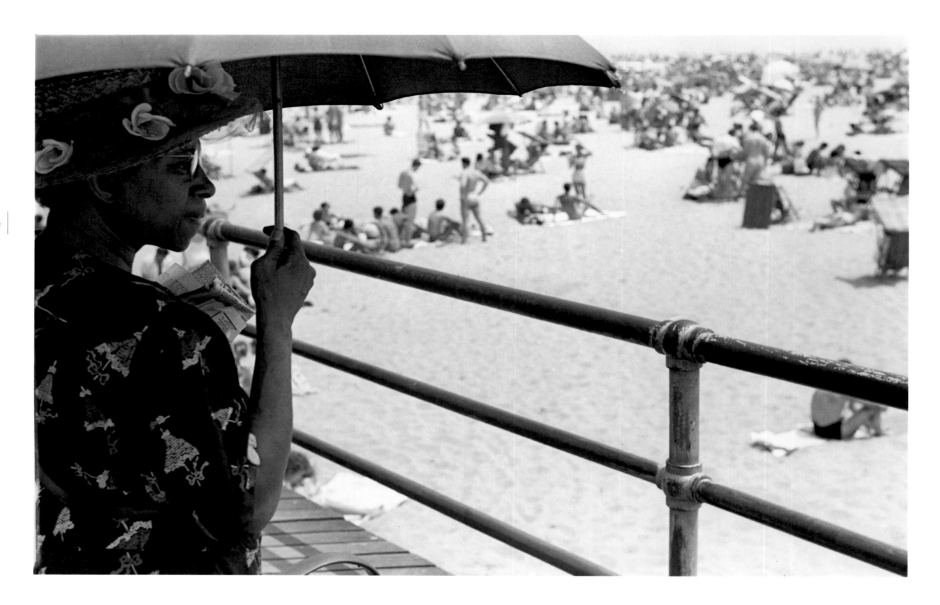

48 *Coney Island,* July 30, 1949

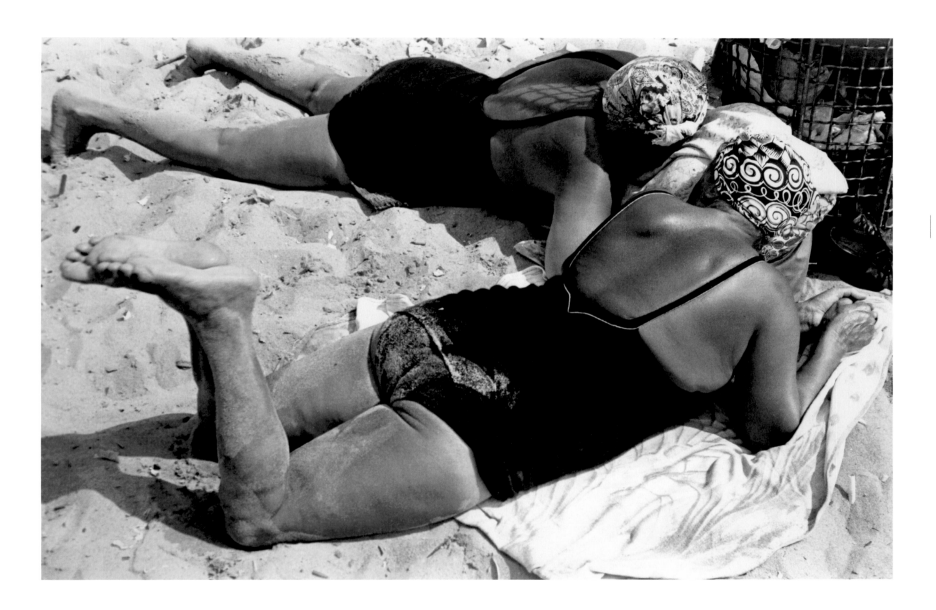

49 *Coney Island*, July 30, 1949

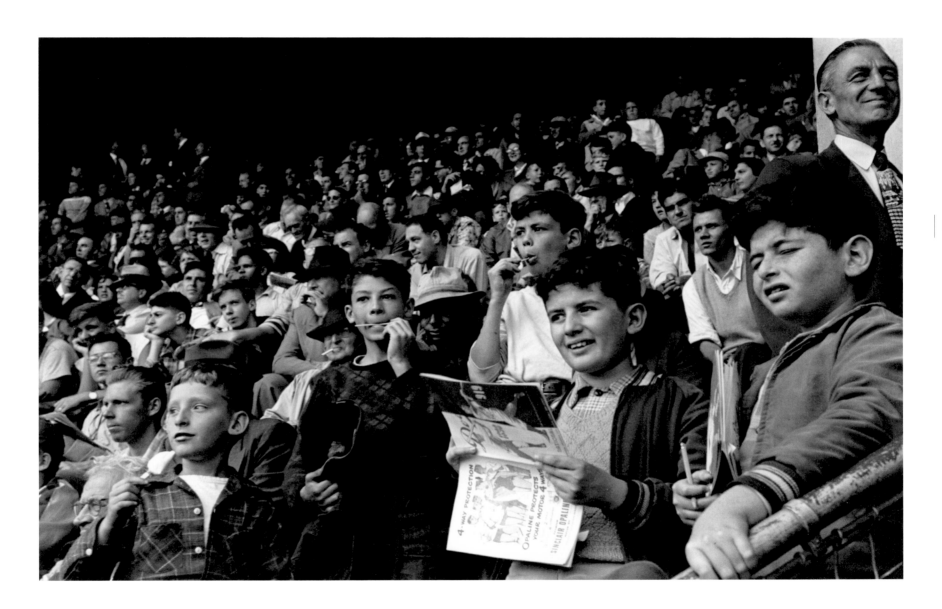

50 *New York*, September 9, 1949

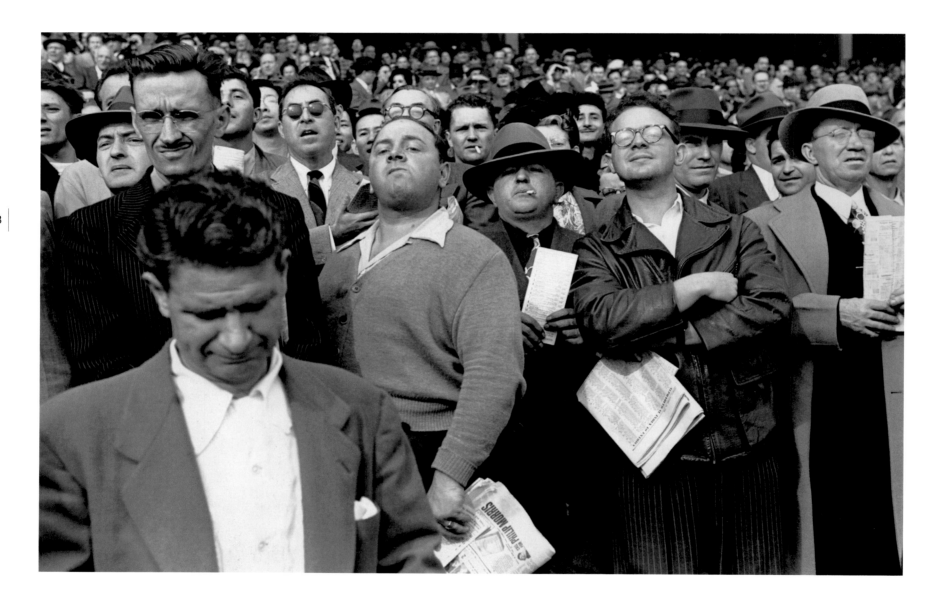

51 *New York*, October 29, 1949

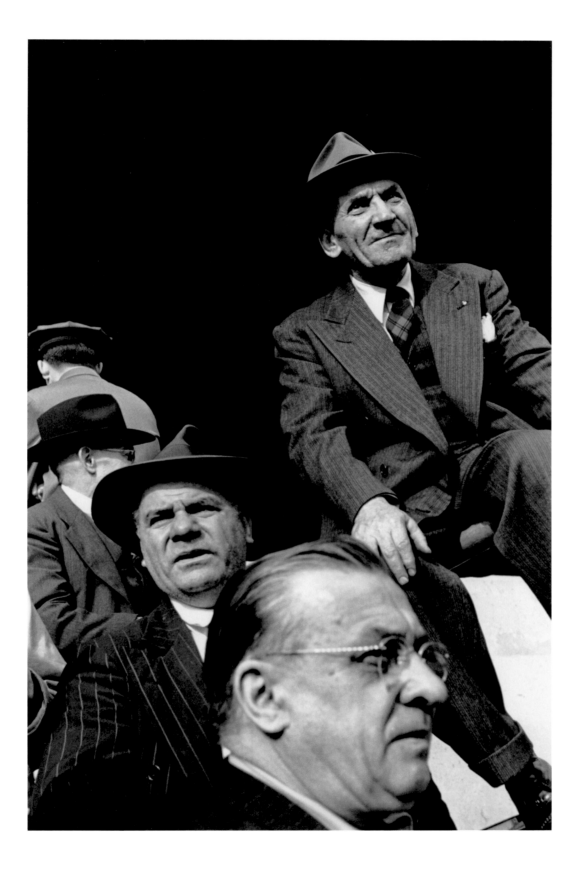

52 *New York*, October 29, 1949

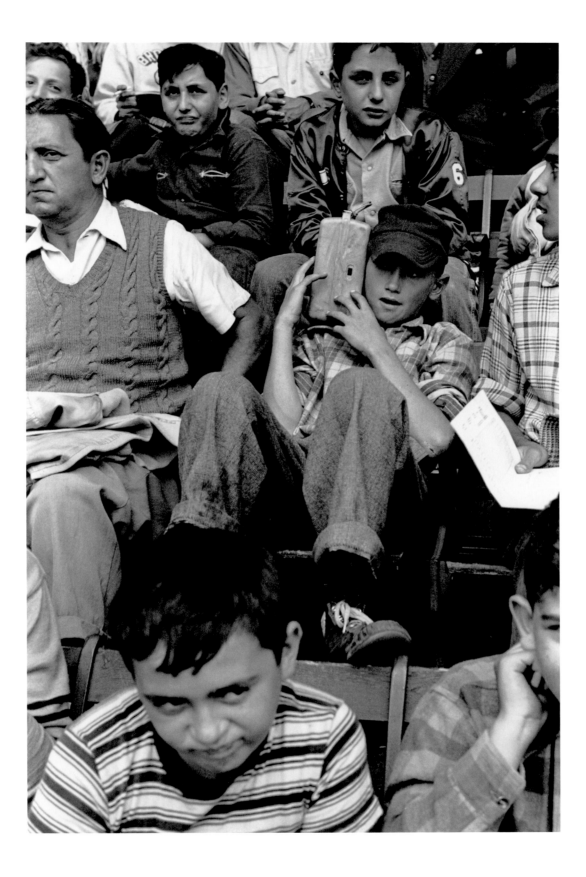

53 *New York*, September 9, 1949

54 *New York*, June 10, 1949

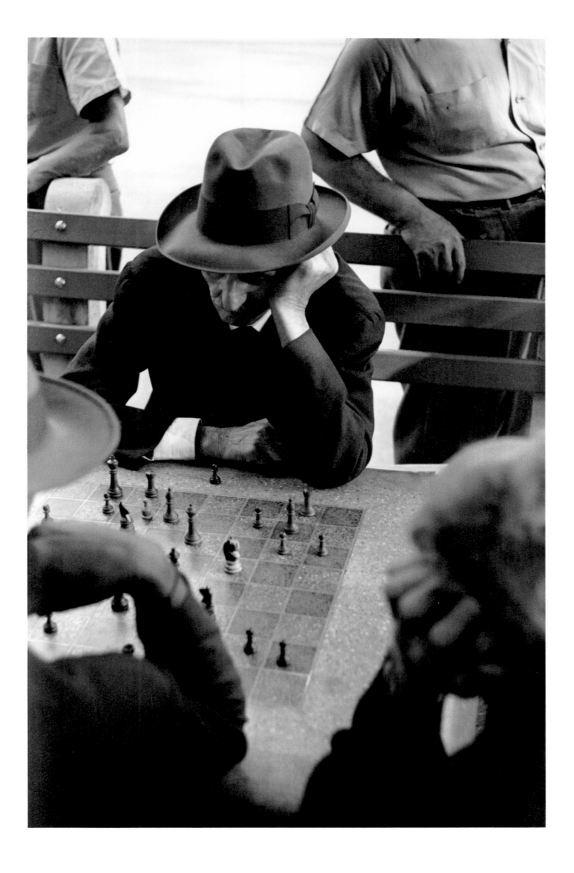

55 *New York*, August 26, 1949

56 *New York*, June 10, 1949

57 *New York*, May 31, 1949

58 *New York*, September 9, 1949

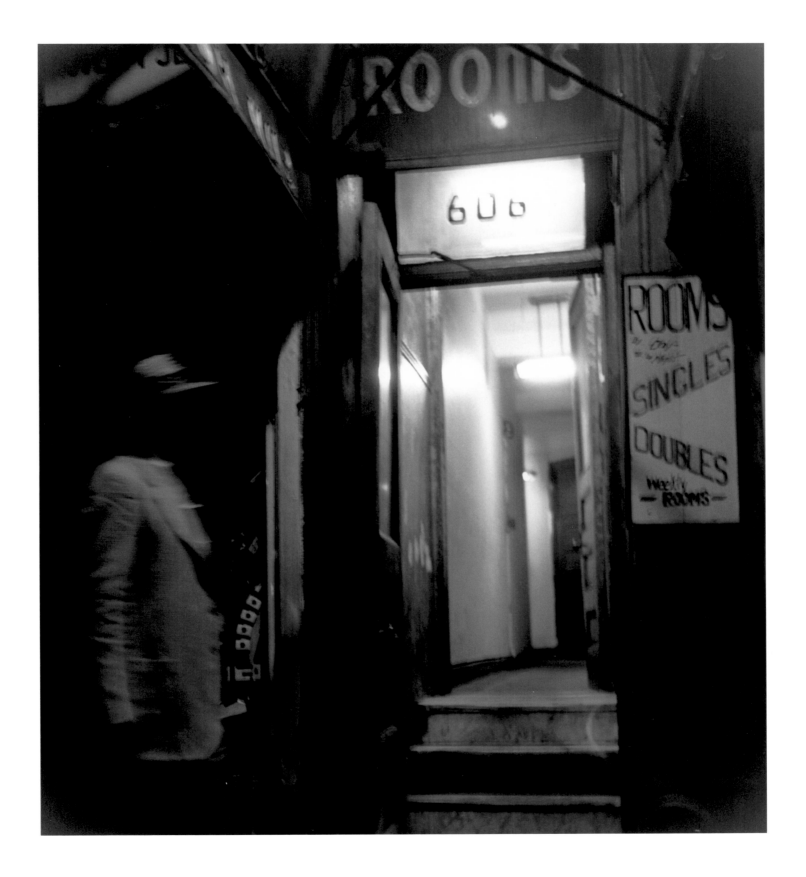

59 *New York*, June 19, 1949

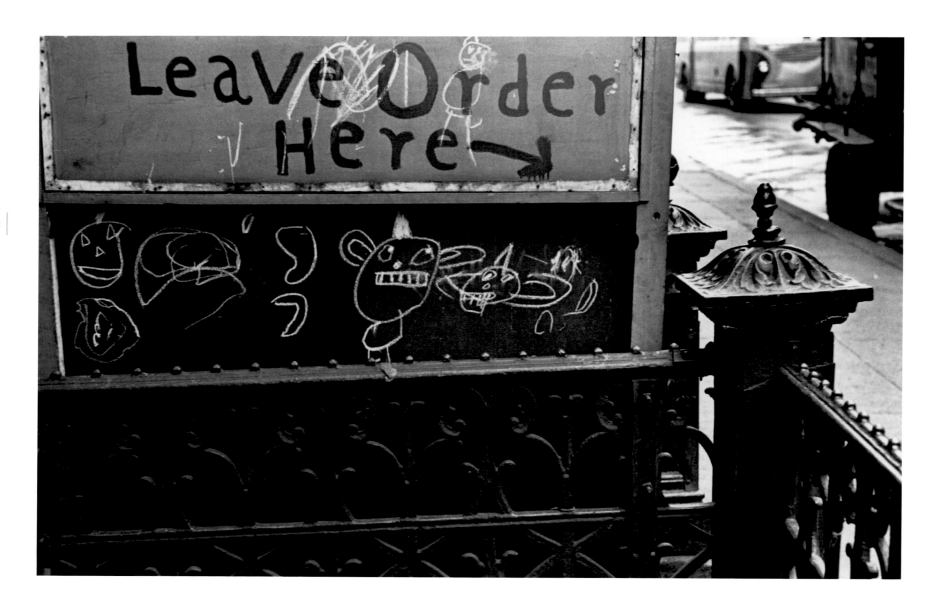

60 *New York*, October 25, 1949

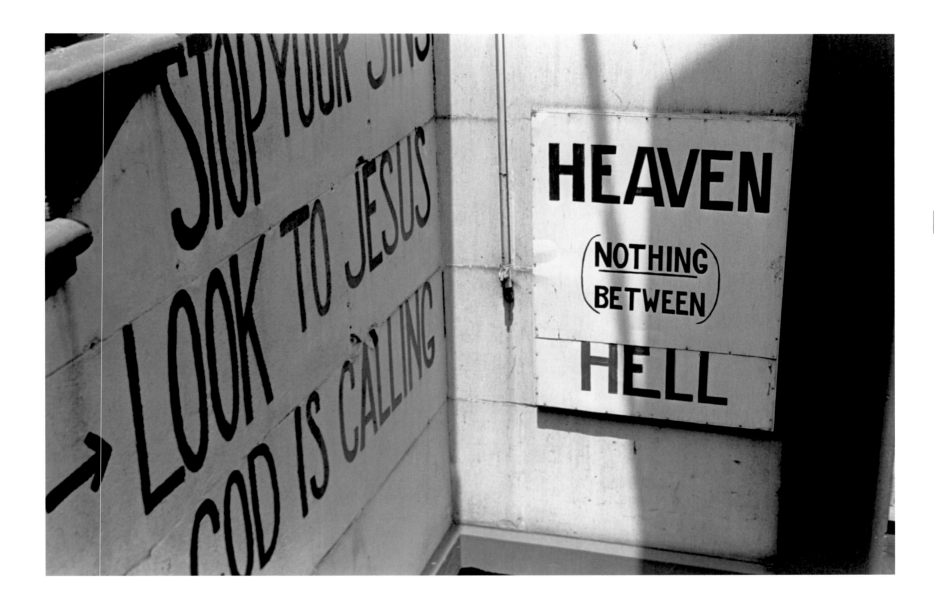

61 *New York*, May 31, 1949

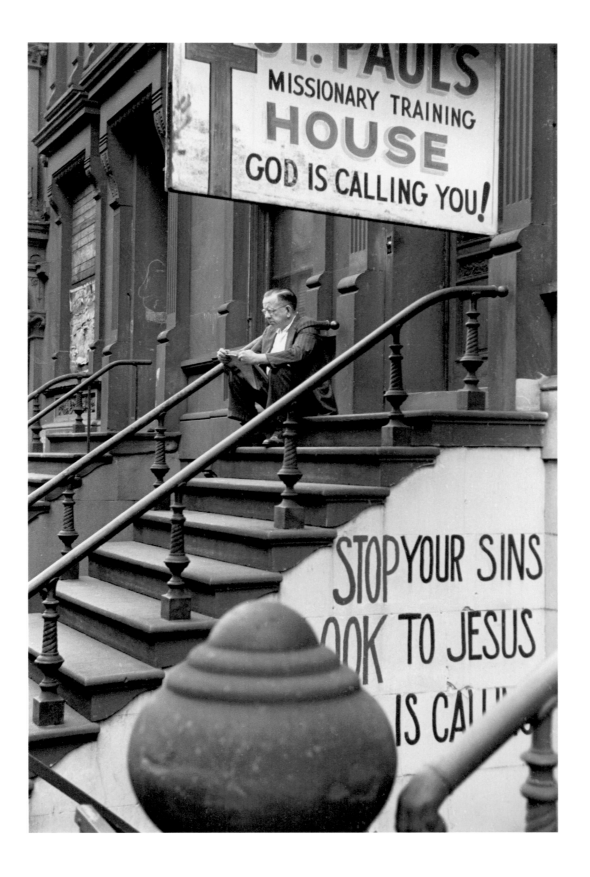

62 *New York*, May 28, 1949

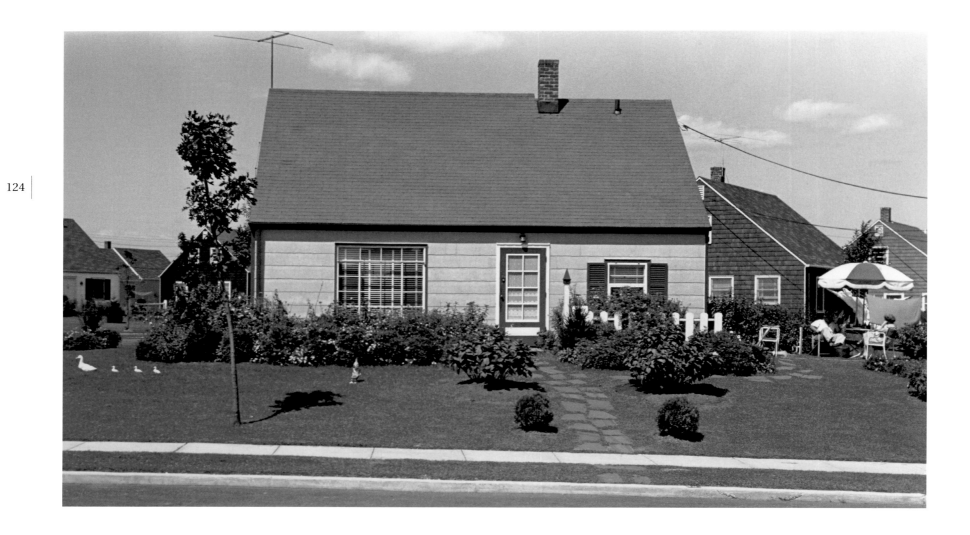

63 *Levittown, Long Island,* August 20, 1949

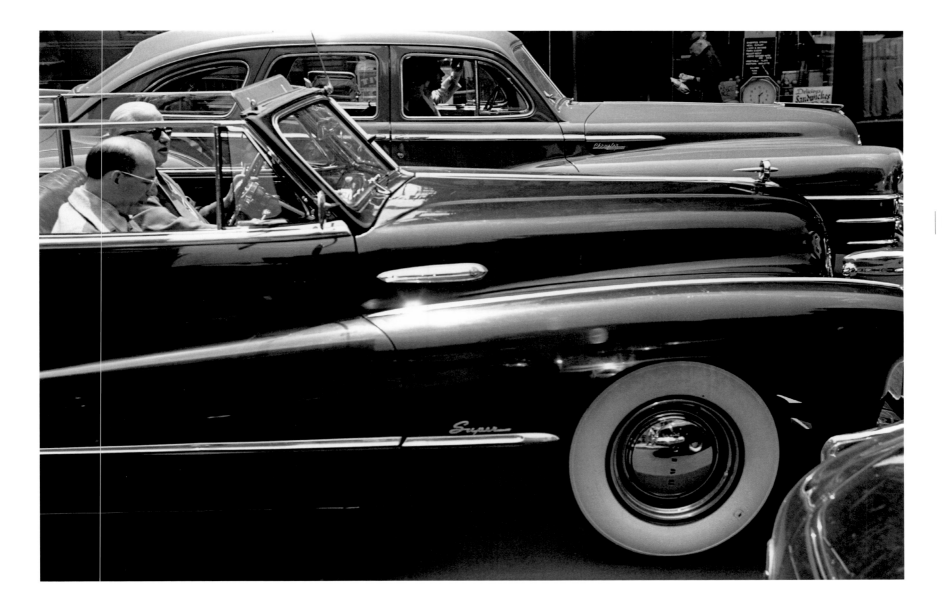

64 *New York*, May 31, 1949

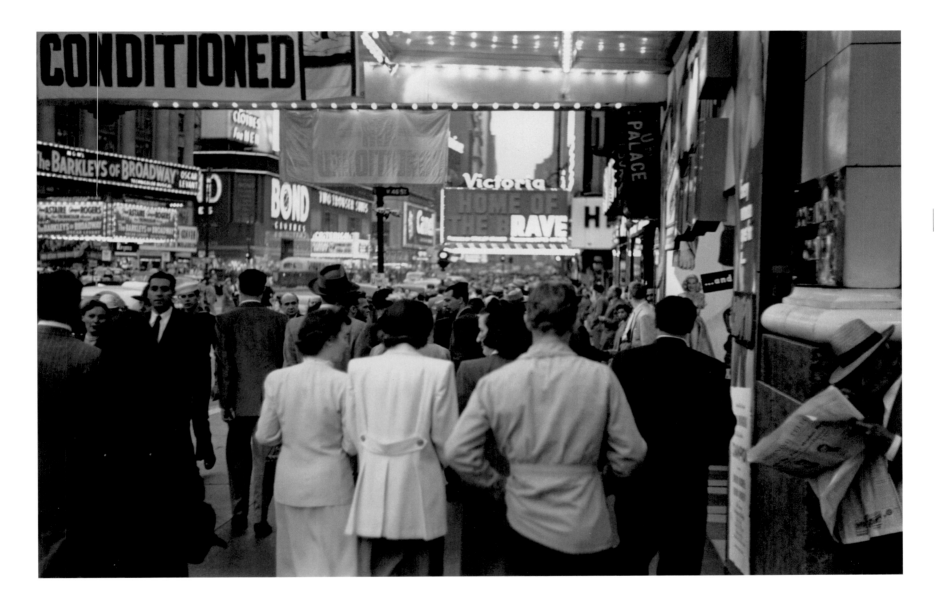

65 *New York*, June 10, 1949

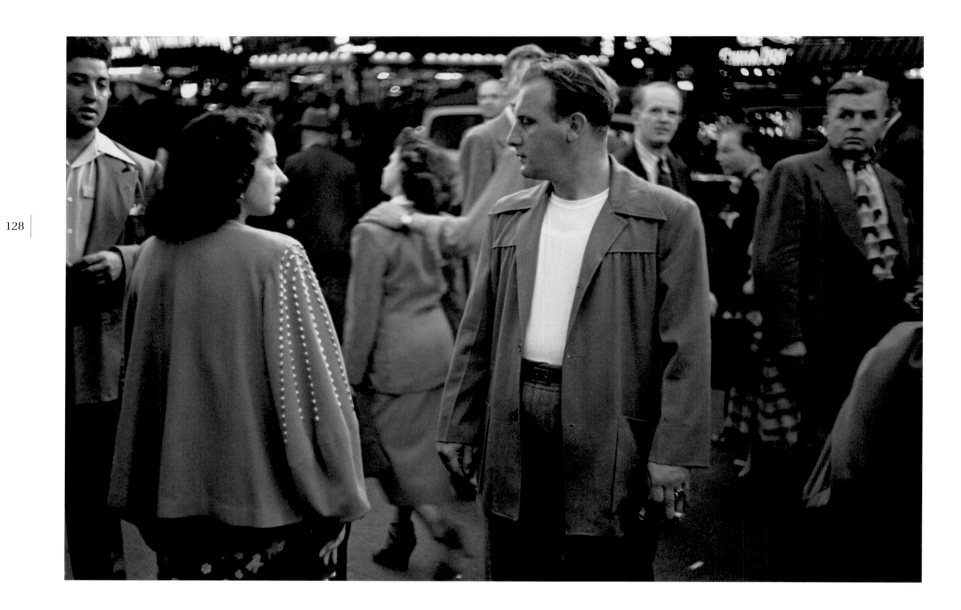

66 *New York*, June 11, 1949

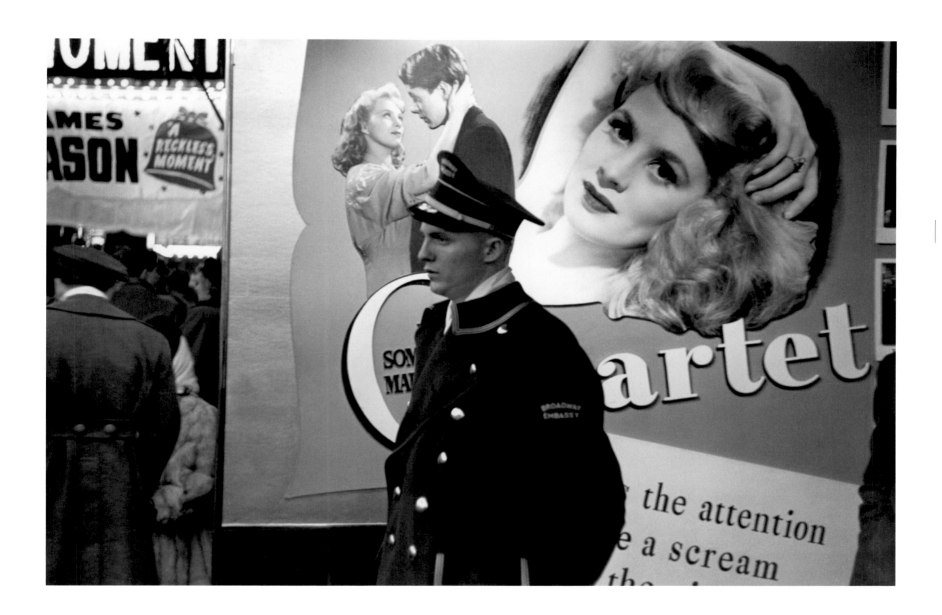

67 *New York*, December 31, 1949

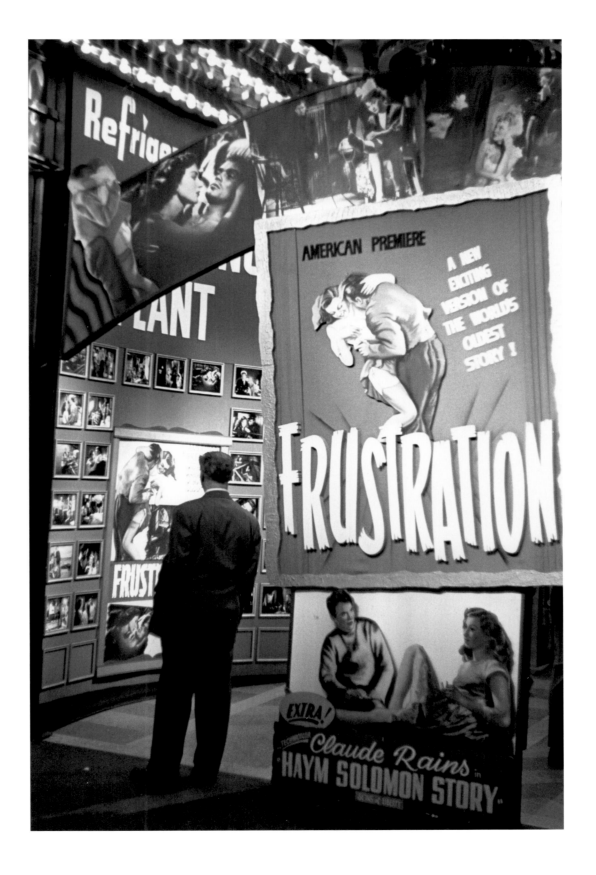

68 *New York*, September 7, 1949

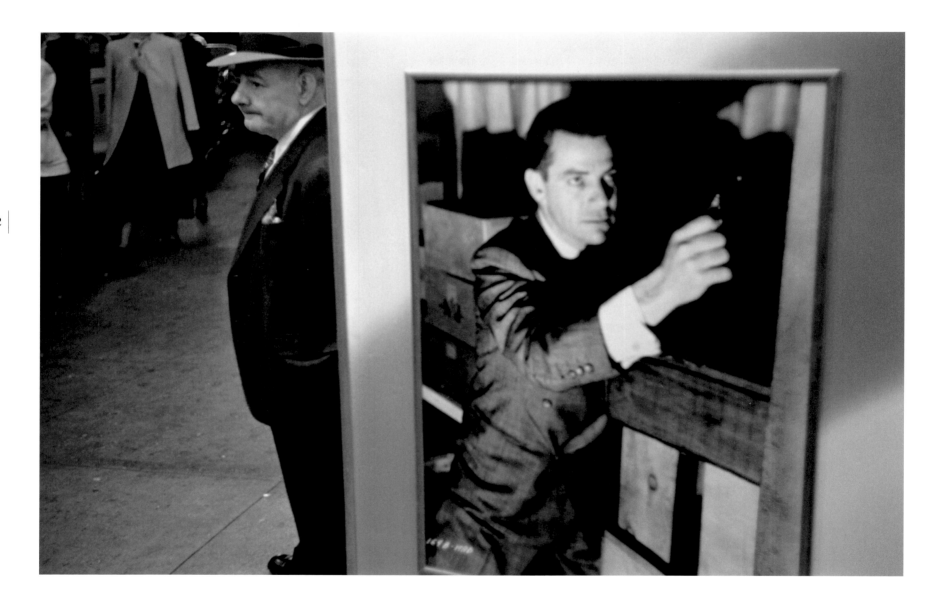

69 *New York,* June 10, 1949

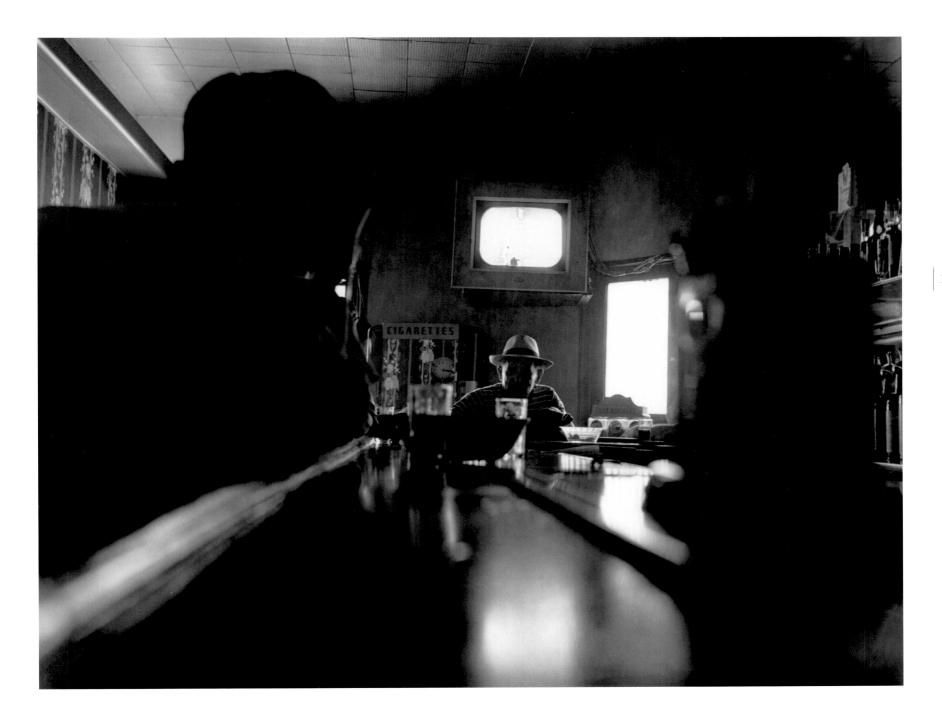

70 *New York*, July 16, 1949

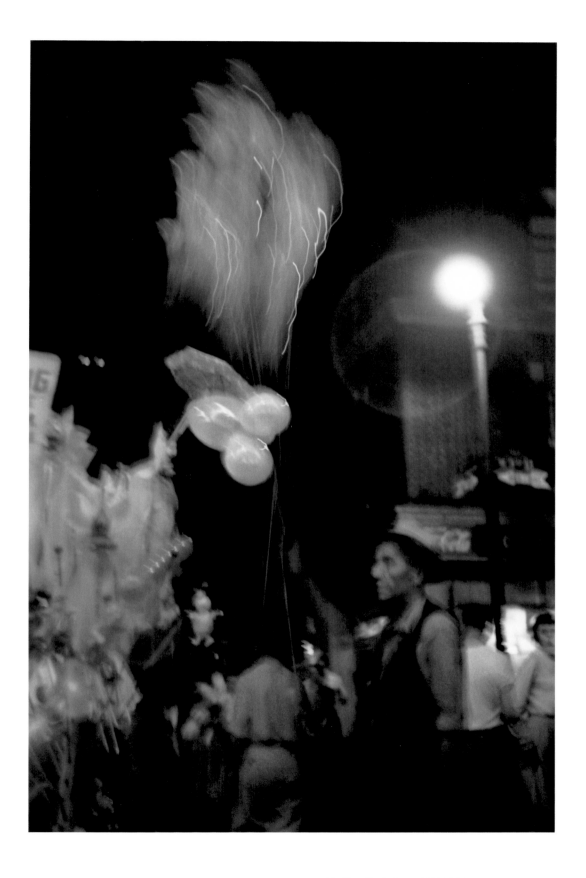

71 *New York*, August 27, 1949

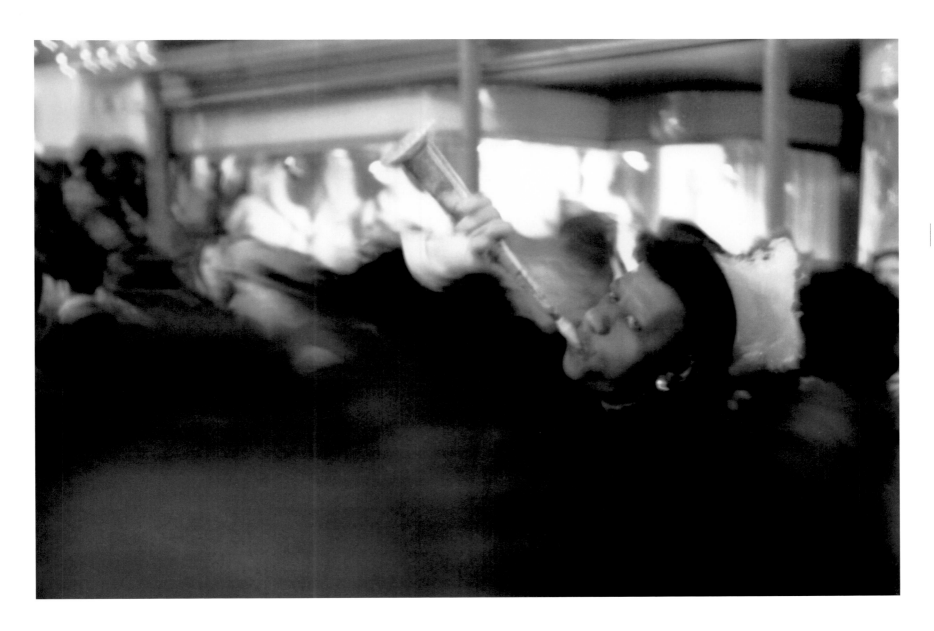

72 *New York*, December 31, 1949

"Introduction," ca. 1947–48
[Documentary Photography Lecture Notes]

APPENDICES:
TEXTS BY
HOMER PAGE

Before beginning on these lectures about documentary photography, it would be a good idea to ask why they are being given at all. My answer to that question is this: the purpose of these lectures is to develop in you an attitude about photography—an attitude about how to use photography. For the difference between a good photographer and a poor one is not so much what each knows about photography, but how he uses what he knows. What he says with it.

You are here developing your technical capacities in order that you may control and use photography to some end—to express yourselves. You are getting an understanding of the possibilities and limitations of your medium so you may use it as a tool to say what you feel. What we will do here is to discuss an attitude about how to use photography. I think it good to keep in mind that whether or not you feel this particular attitude is right for you, this discussion may help you in developing an attitude which is right for you. Therefore, I ask you to think about how these discussions may help you use photography as a means of expressing what you feel about the world around you.

In order to be in a better position to deal with our subject at close quarters, we ought first to place it generally in the scheme of things around it. We should first see what position documentary assumes alongside the other activities around us, and see what relationships it has with these activities. Then we will be in a better position to take our subject apart; to analyze it and evaluate it. So we will first create a frame of reference through which we can all see somewhat the same picture.

I have consciously avoided saying I would define our subject. The reason for this is that I do not think of documentary as a school or technique, whose limits can be neatly circumscribed. But rather, as an attitude which has as its foundations certain working principles. It is our first job to find out what the general scope of this attitude

is, in order to get our minds running along the same channel. With this picture once in mind, we will be in a position to understand more easily the various aspects of its working principles.

Where, then, can we place documentary in the scheme of things around us? I would like to start to do this by asking a question: What are the things around us which are important in our lives?

There are our friends and children; our homes and automobiles and refrigerators; our jobs and working companions; our hobbies and our sports.

There are rising prices; elections; peace conferences and atomic bombs; strikes and lockouts; there is how much money we earn and what we can buy with it.

There is the pleasure of taking a good photograph; of seeing something beautiful; of realizing our potentialities.

Other things too: what our friends think of us; our own peace of mind; whether we think we are successful or not; how soon we can get married, build our own home, or travel around the world.

In fact, there are so many things which are important to us that we are continually forced to select and center our attention on those things which we consider most important at the moment. And that is the point I want to get across. We are forced to choose from the multitude of things around us those things which are important to us and those which are not.

We, as people living in a complex and fast-moving world, also know that there are many important things going on which we cannot experience directly, but which nevertheless affect us. We may never have seen an atomic bomb, but we have no doubt of the importance of it in our lives.

Right here is the ground of documentary photography. It acts to <u>inform</u>, <u>interest</u>, and <u>convince</u> people about things which are important to them, but which they cannot experience first-hand, themselves.

Untitled Lecture, October 1948

In trying to understand my own relationship to the work which has already been done in photography, I have to go back to what has happened in photography in the past, particularly in that branch which has been called "documentary," since my work seems to fall roughly in that category.

Documentary has been defined as "building a record of change, historical recording of society," etc. This in a sense is true, but I believe that such goals for the documentarist have now become invalid and inadequate.

To think of documentary in such a light is to think it into a cul-de-sac.

It is true that the camera is a marvelous instrument for recording a situation, or for recreating elements of American life. But in the process of photographing, unlike what happens to the historian or the social case worker, the photographer assumes a position, not only as an observer, but as a participant. Assessing of values goes on simultaneously with the recording of those values, since very often the seeing of an image and the recording of it have to be practically instantaneous. Assessing goes on intellectually sometimes but also very often it assumes a form of reaction rather than being a judgment. (One's technical capacities, of course, have to be a servant to this process, as much as possible.)

Practically speaking, it is often impossible to evaluate intellectually at the same time that you create; instead, the process becomes more a process of automatic or subconscious selection on the scene at the time of making the exposure.

You photograph what appeals to you on the street. Then you try afterwards to select, organize, and create an overall picture. Some photographers sit down, choose a subject and think of photographs to illustrate or prove their theses. But afterwards, they go through the same process of after-selection.

Actually, this approach is one of an artist, rather than that of a scientist, and therefore it should not pretend to scientific method. It is quasi-scientific, and this method of working distorts the potentials of the medium.

In the above, in which the terms of documentary are defined, photography is the adjunct of the social worker. It is a tool, a supplementary means of supplying information, in the terms in which graphs, charts, etc., are used. It portrays statistics visually, in theory.

The graphs, however, have not been based on an evaluation of the material which might be termed "instinctive," as photographs are. They are factual. Photography seems factual, but it also has another dimension, of which one must be aware. Photographs also contain the photographer's reactions to the life about him.

If the photographer is a real artist, his work is accepted because it gives new meaning to what may be old

and familiar experience. The documentarist is coming to try to represents the <u>values</u> of our times, rather than the <u>facts</u> of our times, as has been the attempt in the past. A scientific standard was the ideal, something which could not actually be put into practice.

I think the premise that photography can give a historical recording of society is only half right. The photographer is better equipped to give an historical interpretation.

In the past also, photographers have largely used what I call "absolute images," that is, they focused on something and the objects around that object became of lesser importance. The intent was to isolate one image from its surroundings. You photograph a nucleus, in this way, and the rest of the field of vision is peripheral. Much of my work has been done this way, such as the [image of] the woman walking [**FIG. 12**].

This absolute vision is a heritage from the other arts, from a historical point of view. For instance, the Mona Lisa is composed on the basis of a triangle. The conception is one of a basic unit, near the center of the format, and the other things in the painting are peripheral. The modern movement in art generally has broken from this concept, as for instance, in the work of Mondrian.

Documentarily speaking, the absolute image was linked with the idea of catching the prototype, or the absolute example of a moving, fluctuating situation. The photographer attempted to get, as accurately as he could, the prototypes of certain kinds of people, families, jobs, farms, countrysides. If you got an image of a typical one of what you were trying to isolate, "he stood for the group."

Recently, I have been trying to photograph what I call "relative" images, rather than absolute ones, in the center of the format.

The relative image I see when all the things which enter into the composition are noted in their relationship to each other. The image is in terms of the full format. Cartier-Bresson's work has come to the refinement of being able to see this sort of thing immediately, so that he catches it on the film without the necessity of cropping afterwards, during the printing process. The relative image exists because of relationships.

We all see absolutist images very quickly because we are trained to them and are accustomed to accepting them. Most of my photographs of this sort are much more readily accepted. I believe, however, that my relativistic photographs come closer to portraying my own sense of reality, although their worth is not so easily judged by most untrained people or people trained in absolute visual concepts.

The trend toward a non-absolutist concept seems to be true in many fields. Darwin was probably the forerunner of the idea of not having an absolute heritage, in the field

of science. He challenged the authority of the church with his concepts, an authority based on absolute dogma which was supposed to be accepted without question. It was the challenge to an absolutist standard. Darwin's idea was relativisitic. Einstein furthers relativisitic ideas. He did it in the field of physics but its importance lies in its being widely accepted as a concept by a larger group of people.

I believe that an important aspect of our existence is to be found in relationships, that is, in the nature, or configurations of relationships. Many things have to be understood in terms of how they relate to other things rather than by trying to isolate them in order to examine them. Cartier-Bresson does an admirable job of catching people's relationships. In these general terms, I am trying to capture some of these same things.

I am interested in the visual manifestations of the inner forces of people, and how those inner forces are manifested toward other people and things. I want to photograph social pressures, physical pressures, cultural pressures, and how people react to them. I am trying to do this by adjusting the terms in which I see the image on the film.

I would like to try to go further still with this idea of relativism. Further, that is, than changing the type of image from the customary approach. I have come to believe that photography is now at a stage where it must make a complete statement by investigating the idea of relativism not only in the single image, but in series of images.

I am coming to think that photographs shown in series build up an intangible but nevertheless real experience which exceeds the outlines of the individual people shown in each photograph. The experience grows if the photographs are so arranged that each visual image reinforces and amplifies the ones next to and beyond it. Each becomes relative to the other, some perhaps are supplementary to others, but at any rate, the series should be composed with the thought that probably the image does not linger in the mind of the onlooker, but the idea which the image invokes is probably held over in time as the eye proceeds to the next photograph in the series. In the terms of other arts, a series of photographs could probably be presented in which the carry over factor is utilized to produce a form in the work—the series could be made, perhaps, to rise to a climax, and then fall off, as the action in a novel does. The internal organization should make it possible for the meaning of the work to be greater than the simple sum of the photographs.

Guggenheim Fellowship Application statement, Nov. 1, 1948

PROJECT

About four years ago, I started a photographic inquiry into city life which has evolved by successive selections into two phases. First, to photograph the qualities of the relationship between urban people and the cultural forces which surround them; second, to organize these pictures into a dramatic form that has a flow of development. This project, then, will be presented under these two headings: first, THE MEANING; second, THE FORM.

I sincerely believe this inquiry has reached a stage where it should absorb my undivided time and energy. I am not free to give this, however, without financial assistance.

* * *

THE MEANING

This urban society, like all others, has its particular standards of behavior embodied in its institutions, codes, and customs. Our people are introduced to these standards at childhood, and are expected to conform to them. Not only do the people conform to these standards, but they absorb and perpetuate them as well. They form hopes and ambitions around them; they judge success and failure by them.

Human energies are thus directed into social channels. These channels should, in turn, offer release for those energies. At this point, where our requirements as human beings and the demands of our culture meet, I propose to photograph. For here, we see how well or poorly our society satisfies the needs of its people, and how adequately the people respond to the pressures put upon them. Here too, the defensive barriers to inner lives are often lowered, and a glimpse is caught of desires and dreams confronting directly the forces which both created them and would destroy them.

The standards we hold, such as the ones concerning material well-being or personal achievement, are visually apparent on every hand. They are personified in faces, dress, and actions all about. This inquiry would not attempt to judge their values in terms of other societies or other times. Nor would it attempt to analyze the structure of the institutions or the character of the customs. It would attempt, however, to show their meaning in terms of human hope and despair, joy and sorrow. It would attempt to show the mark of these forces imbedded in the people. It would attempt to document people's reactions of surmounting, submitting, to, or evading these forces at their point of impact; to show the social devices operating to assist these reactions. It would attempt, in short, to cut below the surface and reveal the core of the relationship between urban people and the standards by which they live and die.

* * *

Any inquiry of this kind could not, by its nature, be comprehensive or complete. Rather, it would draw from various facets of the situation in different proportions. The proportions would be determined primarily by their importance in the lives of the people, but also by their visual availability. How such material could be dealt with, visually, must be shown by my photographs.

* * *

THE FORM

The use of photographs to communicate knowledge and ideas is of growing importance. It is a curious fact, however, that in spite of enormous strides taken in many parts of this field, only a few efforts have been made to mold and unify individual photographs into a complete form of expression. Such a form must be forthcoming if the photographer is to be accepted as a person capable of making a full statement about what he sees and feels. Otherwise, he will remain in the position of being able to show only disjointed fragments of his total concept.

This form should function to present the photographs as clearly and powerfully as possible, since the importance of this project lies squarely upon the photographs and their meaning. The form should act to organize and reveal this meaning.

The logical conclusion to the completion of this project would be its publication in book form. The ultimate proof of its worth would be its acceptance and appreciation by the people about whom it is concerned.

"Documentary Today," May 8, 1949
[Notes for Lecture at the New York Photo League]

American documentary photography is in the doldrums today. The vital force it inherited from the FSA Group of the 1930s has been dispersed and lost. It is hard now to find significant photographic documents of contemporary life, and any widespread and integrated documentation of our country does not exist. There are may causes for this condition, and many problems involved in any solution of it.

I. Most important among these CAUSES, I believe, is the present confusion of facts and values

 A. We are not sure of war or peace, prosperity or recession; not sure what balance to strike between our freedom and our security, either as a nation or as individuals. The fundamental issues are clouded and almost certainly in transition.

 B. This makes any attempt to record conditions extremely difficult. This also makes it difficult for any pervasive documentary movement to find a common footing, since such movements in the past have generated from relatively clear-cut situations such as war or depression.

II. As to the specific PROBLEMS which any full-fledged rejuvenation of the documentary spirit must face, two seem to me very important

 A. The field into which documentary looks must be expanded in order to record important aspects of life not before seriously considered.

 1. Most documentaries of the past have had a physical frame of reference such as a geographic area, an income group, a specific situation, etc. This method of viewing subject matter, although a necessary facet of the documentary approach, has limitations which prevent us from dealing with many significant aspects of life.

 2. If, for example, confusion of values is an important part of our life today, we must analyze and record this confusion, the forces which cause it, and its effect on the people. This can only be done by cutting across the conventional boundaries of selection that past practice has drawn, and photographing those new areas (while still maintaining the distinctive standards of sincerity and authenticity upon which documentary photography is based).

 3. On the urban scene, this implies seeking out aspects which cities have in common, rather than defining the unique characteristics of any particular city.

 4. For example, we should consider such conditions as the rising tempo of living in cities, shifting family and marriage relationships, present standards of success (and failure), increasing standardization of food, clothes, recreation, news, etc. We should not only consider the causes of such conditions, but their effects found imbedded in the people.

 B. The final form which documentary work takes must not be left to chance, but consciously developed.

 1. We should give up the idea that a miscellaneous collection of prints on one subject constitutes a coverage, and thoroughly consider the finished product (book, article, or exhibition) before starting the coverage. If we are to make a full statement about our subject, we must develop a finished form and work with that form in mind.

 2. In terms of communication, we should create visual form which functions for the photographer as the essay, short story, or novel function for the writer, namely, to provide a framework within which an idea can be properly developed. (It is interesting to note here that writers do not expect— or get—their work hacked up and scrambled in publication to the extent most photographers have come to accept.)

 3. Specifically, solutions must be sought for at least two problems of form.

 a. The relation between word and pictures must give each medium a chance to be used to its optimum power. Words must not merely underline what has already been expressed visually by the photographs.

 b. The bond between succeeding photographs in a series must be strengthened to create a "flow" of meaning. This "flow" would provide the necessary plastic quality needed to mold a set of photographs into a form having more meaning than the sum of the individual pictures, just as a story is more than the sum of its words.

The record of contemporary life which documentary photography can provide is an important contribution to the development of a democratic people. It can only be provided by the participation of many people and the convergence of their ideas. We must pool our efforts through such organizations as the Photo League, enlarging our capacity to record the life around us, in order to create a penetrating, accurate, and lasting document of our times.

Homer Page
May 8, 1949

SELECTED BIBLIOGRAPHY

1944

Ansel Adams, "With the Critic," *U.S. Camera* 7 (August 1944): 44 (brief commentary by Adams on Page's photograph *San Francisco War Workers*).

1946

Christiana [sic] Page, "The Reluctant Reformer," *Minicam* 9 (February 1946): 50–57, 144 (eight photographs by Page).

Beaumont Newhall, "Dual Focus," *Artnews* 45 (June 1946): 36–39, 54 (review of MoMA exhibition; one photograph by Page).

"Creative Camera Men," *Newsweek*, July 1, 1946, 81 (review of MoMA exhibition; one photograph by Page).

1947

Coronet 21 (February 1947): 124–25 (two photographs by Page: *Ultimatum* and *Tomorrow Is Another Day*).

PM Magazine, October 1947 (review of "Three Young Photographers" exhibition).

Tom Maloney, ed., *U.S. Camera 1948* (New York: U.S. Camera, 1947), pp. 292 (one photograph by Page, from San Francisco "American Legion" series).

1948

"Photography Department," *Museum of Modern Art's 19th Annual Report* 15:4 (1948): 15 (one photograph by Page).

"Speaking of Pictures," *Life*, May 10, 1948, 14 (on MoMA exhibition "In and Out of Focus," with one photograph by Page).

Alfred Frankenstein, "Photography, Music and Some Painting," *San Francisco Chronicle: This World*, June 20, 1948, 23–24 (one photograph by Page).

"Fifty Photographs by 50 Photographers," *Vogue Magazine*, August 15, 1948 (on MoMA exhibition; one photograph by Page: *Man Looking Up*).

Tom Maloney, ed., *U.S. Camera 1949* (New York: U.S. Camera, 1948), pp. 32–33 (on MoMA exhibition "In and Out of Focus"; two photographs by Page).

1949

Tom Maloney, ed., *U.S. Camera Annual 1950* (New York: U.S. Camera, 1949), pp. 193, 215 (two photographs by Page: *The Black Cat Bar* and *Broadway, New York*).

1950

Tom Maloney, ed., *U.S. Camera Annual 1951* (New York: U.S. Camera, 1950), pp. 206–07 (two photographs by Page: *Racetrack Spectators* and *Subway Exit*).

1951

"What Is Modern Photography?" *American Photography* 45 (March 1951): 146–53 (edited transcript of MoMA symposium; one photograph and commentary by Page, p. 151).

John Stuart Martin, "Men Against Rock," *Argosy*, May 1951, 40–43, 96–98 (six photographs by Page).

Jim Vargyas, "Hot Steel," *Argosy*, June 1951, 30–33, 90–91 (five photographs by Page).

"World's Most Important Miners," *Argosy*, October 1951, 20–23, 87 (photo-essay on uranium mining in Utah; six photographs by Page).

Homer Page, "Timber Up the Hill!" *Argosy*, December 1951, 24–29 (nine photographs by Page).

1952

"Home From Korea," *Harper's Bazaar*, April 1952, 112–13 (mention of Page in "Editor's Guest Book," p. 70, and reproductions of two photographs from series on war amputees).

Herbert Solow, "The Congo Is in Business," *Fortune*, November 1952, 106–12, 165–68, 170, 172 (seven photographs by Page).

Tom Maloney, ed., *U.S. Camera 1953* (New York: U.S. Camera, 1952), pp. 164–65; (from "MoMA Christmas Show"; one Page photograph reproduced: *Amputee from a Place Called 'Korea'*).

1953

"Look Out Below!" *Adventure*, October 1953, 18–21.

Jim Vargyas as told to Walter Ross, "Hot Steel," *Adventure*, December 1953, 28–31, 56 (five photographs by Page).

Catalogue of the Exhibition of Contemporary Photography (Tokyo: National Museum of Modern Art, 1953), pp. 10, 36 (catalogue of Museum of Modern Art loan exhibition to the National Museum of Modern Art, Tokyo, August 29–October 4, 1953; brief biography and reproduction of Page's *Lumberjack*, one of three works in exhibition).

The West: A Portfolio of Photographs (Colorado Springs: Colorado Springs Fine Arts Center, 1953) (exhibition portfolio of offset reproductions; includes Page's *Ace Turner, Uranium Miner (Utah)*).

1954

Oden Meeker, *Report on Africa* (New York: Charles Scribner's Sons, 1954) (includes a "credit to Homer Page" for helping with the photographic illustrations and one identified photograph by Page, between pp. 86 and 87).

1955

Homer Page, "Men at Work," *Candid Photography No. 263* (1955): 4–11 (eleven photographs by Page).

"Coney Candids," *Candid Photography No. 263* (1955): 36–39 (seven photographs by Page).

Carlton Brown, *Famous Photographers Tell How* (Greenwich, Conn.: Fawcett, 1955), pp. 76–91 (portrait of Page, biographical text, and reproductions of twenty-two photographs).

"The Changing Land," "Congo Cargo," "Serving New Frontiers," "Bush Salesman," *Texaco Star* 42:3 (1955): cover, 2–7, 10–15, 16–19, 20–23 (issue devoted to Africa; all fifty photographs by Page).

Edward Steichen, ed., *The Family of Man* (New York: Museum of Modern Art, 1955), pp. 46, 61, 73, 74, 83, 130, 155, 171, 188 (nine photographs by Page).

1956

"Birth of a Nation," *Jubilee*, January 1956, 8–13 (article on Nigeria; twelve photographs by Page).

Homer Page, "Candid Portraits," *Candid Photography No. 318* (1956): 4–8 (seven photographs by Page).

Profile of a Giant (New York: Industrial and Public Relations Department, The Texas Company, 1956) (twenty-four-page pamphlet on West Africa, with forty-six photographs by Page).

1957

"The Search for Jungle Oil," *Texaco Star* 44 (Winter 1957–58): 11–22 (issue devoted to Sumatra; twenty-seven photographs by Page)

1958

Photography of the World (Tokyo: Heibonsha, 1958) (survey of American work, with two photographs by Page, pp. 107–08).

Tom Maloney, ed., *U.S. Camera 1959* (New York: U.S. Camera, 1958), pp. 24–25 (article on MoMA exhibition "Seventy Photographers Look at New York," with reproduction of Page's *Balling*).

Mental Health: A Ford Foundation Report (New York: Ford Foundation, 1958) (booklet with twenty-seven photographs by Page).

"The Quality of Mercy: A Nun's Story in Pictures," *Pageant*, January 1958, 22–29 (photo-essay on Mother Theresa; eleven photographs by Page).

1959

Oden Meeker, *The Little World of Laos* (New York: Charles Scribner's Sons, 1959) (on title page: "With a Picture Essay by Homer Page." This essay is composed of twenty-three reproductions on a special twenty-page signature between pp. 96 and 97. A second photo-essay comprises nine reproductions on an eight-page signature between pp. 192 and 193. Note on copyright page: "About one-third of this book has been expanded from an article: Oden Meeker, 'Don't Forget Madame's Elephant,'" *Saturday Evening Post* 228 (January 14, 1956): 30, 64–65, 68; the three photographs with this article are uncredited).

1960

Mira Rothenberg, "The Rebirth of Jonny," *Harper's*, February 1960, 57–66 (article on childhood schizophrenia; all eight photographs by Page).

Leslie Lieber, "Eight 'Shangri-Las' (for People with Dreams)," *Philadelphia Sunday Bulletin: This Week Magazine*, August 7, 1960, 6–9 (cover photograph of Bombay boats by Page).

Homer Page, "The Burma Surgeon Fights On," *Think*, September 1960, 16–20 (seven photographs by Page).

1961

Arthur Herzog, "A Visit with Ralph J. Bunche," *Think*, January 1961, 23–27 (four photographs by Page).

Homer Page, "Three-Pronged Attack on Cancer," *Think*, June 1961, 12–15 (three photographs by Page).

Homer Page, "A New Element Is Born," *Think*, September 1961, 2–5 (article about research in nuclear physics; six photographs by Page).

Homer Page, "Puerto Rico: Self-Help Showcase," *Think*, October 1961, 22–26 (six photographs by Page).

"Trinidad: A Five Year Report," *Texaco Star* 48 (Winter 1961–62): cover, 2–10 (issue devoted to Trinidad; twelve photographs by Page)

1962

Homer Page, "Proving Ground for Recruits," *Think*, May 1962, 8–12 (four photographs by Page).

The Society of the Streets (New York: Ford Foundation, 1962) (three photographs by Page, on cover and pp. 7–8).

"In Alaska—A Market Takes Shape," *Texaco Star* 49 (Winter 1962–63): 2–5 (six photographs by Page).

1963

Homer Page, "Art as Investment," *Think*, February 1963, 15–17 (one photograph by Page).

Homer Page, "Alaska Today: People, Problems, Promise," *Think*, March 1963, 7–10 (six photographs by Page).

Homer Page, "Probing the Secrets of the Deep," *Think*, November–December 1963, 7–9 (article on Scripps Institute in La Jolla, Calif.; four photographs by Page).

Homer Page, *Puerto Rico: The Quiet Revolution* (New York: Viking, 1963) (167-page book; all text and photographs by Page).

1964

Homer Page, "A Visit with Albert Szent-Györgyi," *Think*, September–October 1964, 25–28 (article on cancer research; two photographs by Page).

Homer Page, "We Can Beat J.D.," *Parents' Magazine*, October 1964, 57–58, 90–92, 94 (article on juvenile delinquency; five photographs by Page).

Homer Page, "Young Rebels with a Cause," *Parents' Magazine*, December 1964, 42–45, 112 (article on the civil rights work of the Student Nonviolent Coordinating Committee; seven photographs by Page).

1965

Homer Page, "The Man Who Builds Monuments," *Think*, May–June 1965, 19–23 (profile of Philip Johnson; six photographs by Page).

Homer Page, "A Remembrance of Dorrie," *Infinity* 14 (November 1965): 26–27 (remembrance of Dorothea Lange, with a portrait of her by Page).

1966

"Comeback from a Quake," *Texaco Star* 53:1 (1966): cover, 2–7 (story on recovery from 1964 Alaskan earthquake; eight photographs by Page).

"The John Simon Guggenheim Memorial Foundation Fellows in Photography, 1937–1965," *Camera* 4 (April 1966): 6, 30, 31 (two photographs by Page, with a brief biography).

An Exhibition of Work by the John Simon Guggenheim Memorial Foundation Fellows in Photography (Philadelphia: Philadelphia College of Art, 1966), pp. 6, 30–31 (catalogue for exhibition on view April 5–May 13, 1966; brief biography and reproductions of two Page works).

1974

Homer Page, "A Faint Image of the Wild World," *Natural History* 83 (January 1974): 90–93 (Page's review of Milton Rugoff's book *The Wild Places: A Photographic Celebration of Unspoiled America* [Harper & Row, 1973]).

1999

Keith F. Davis, *An American Century of Photography, From Dry-Plate to Digital; The Hallmark Photographic Collection, Second Edition, Revised and Enlarged* (Kansas City: Hallmark Cards/Harry N. Abrams, 1999), pp. 260–61, 285–88, 293, 313, 350–51 (numerous text references to Page, with reproductions of three photographs).

2002

David Travis and Elizabeth Siegel, eds., *Taken by Design; Photographs from the Institute of Design, 1937–1971* (Chicago: Art Institute of Chicago/University of Chicago Press, 2002), pp. 119, 243 (a definitive study of the photography program of the Institute of Design, with reproductions of two photographs by Page, p. 119, both San Francisco images made ca. 1947; with a brief biography on p. 243).

2006

Stephanie Comer and Deborah Klochko, *The Moment of Seeing: Minor White at the California School of Fine Arts* (San Francisco: Chronicle Books, 2006) (a definitive study of this program, with numerous mentions of Page, a portrait of him by Milton Halberstadt, p. 38, and reproductions of seven of his photographs, pp. 171–77).

144

This book was designed
and set in type by
Malcolm Grear Designers,
Providence, Rhode Island.

The typefaces are Utopia and Frutiger.
Printed on Scheufelen PhoeniXmotion Text
with Brillianta bookcloth and
Neenah Classic Crest endpapers.

Primary digital photography by
Imaging Services, The Nelson-Atkins
Museum of Art.

All reproductions are 300-line tritones
from separations by
Thomas Palmer, Newport, Rhode Island.

Two thousand hardcover copies
were printed at Meridian Printing,
East Greenwich, Rhode Island,
and bound by Acme Bookbinding,
Charlestown, Massachusetts.

February 2009